# WRITINGS OF THE LOWCOUNTRY

# WRITINGS OF THE LOWCOUNTRY

## Reflections on the South Carolina Coast

# SUZANNAH SMITH MILES

CHARLESTON    LONDON

the
History
PRESS

Other local history books by Suzannah Smith Miles:

*The Beach*
*A Gazetteer Containing a Concise History of the People, Places and Events of the Area known as East of the Cooper*
*Island of History: Sullivan's Island from 1670-1860*
*Time and Tides on the Long Islandxe "Long Island": Isle of Palmsxe "Isle of Palms" History, Flora and Fauna*
*The Sewee, Island People of the Carolina Coast*
*Scoundrels, Heroes & the Lowcountry Outdoors*
*Writings of the Islands*
*Writings of the Past*

Published by The History Press
PO Box 22423
Charleston, SC 29403
866.223.5778
www.historypress.net

First published 2004

Manufactured in the United Kingdom

ISBN: 1-59629-003-X

Library of Congress CIP data applied for.

# CONTENTS

# Preface

CENTURIES OF WARS, REPEATED HURRICANES, an earthquake that was larger than the one that hit San Francisco—the Carolina Lowcountry has seen one disaster after another. As I re-read the articles chosen for this book, I marveled at the area's phoenix-like ability to recover time and again. Such determination!

Yet this firmness of mind is apparently an inherited trait that began with the first colonists at Charles Town. The first years of colonization were grueling. Colonists faced near starvation as they grappled with winters that were unusually cold. The ensuing years presented a series of disasters that would have sent others more faint-of-heart packing. First came a Hugo-sized hurricane, followed by an earthquake, then the colony's first yellow fever epidemic. But they didn't give up and head for home. They struggled on, eventually creating a colony of wealth, sophistication and, perhaps above all else, remarkable endurance.

The soupçon of Lowcountry history presented here will, I hope, offer you a refreshed glimpse into the events and people of this past. "Never a dull moment" may be the appropriate catchphrase for the historic ride Lowcountry history presents. The more dramatic stories told here are hopefully balanced by others reflecting the love we present-day inhabitants have for the beauty and innate elegance of the Lowcountry landscape. And, as always, an occasional animal story is added for just plain fun.

In order to retain the original voices and experiences expressed by the people and publications I have quoted, I have left all spelling, grammar and language as originally written. Where necessary I have added helpful notations.

My thanks to the *Moultrie News, charleston* magazine, and the *Savannah Morning News* for providing me the forums for the original publication of these pieces. And, as always, my deepest appreciation to the staff members of the South Carolina Room at the Charleston County Library, the Charleston Library Society, the South Carolina Historical Society, the Georgia Historical Society, and the Savannah Public Library for their assistance with research.

Suzannah Smith Miles
May 2004

# First Settlement

MORE THAN THREE CENTURIES AGO, the first English colonists who established Charleston arrived. For the ninety-three passengers aboard the ship *Carolina*, making landfall must have been a welcome relief. They had been almost a year on a voyage fraught with storms, shipwrecks and frustrating delays.

With the two other vessels in the fleet, the *Albemarle* and the *Port Royal*, the *Carolina* had set sail from London, then Kinsdale, Ireland, in August 1669. Finally arriving in Barbados in October, the fleet encountered a late-season hurricane. This storm wrecked the *Albemarle*, but the crew was able to obtain a replacement sloop, the *Three Brothers*, and continue on. They next stopped for water at the island of Nevis. Here, providentially, they found Dr. Henry Woodward, often called "the first Carolinian." His story is well worth repeating.

Woodward, originally from Barbados, had been with Captain Robert Sanford's exploratory expedition of the Carolina coast in 1666. Remaining behind to learn more of the land, he had lived with the Indians in the Port Royal region for approximately a year when the Spanish, who had outposts in that region, captured him.

It was thus that Woodward happened to be imprisoned at St. Augustine when the privateer, Robert Searle, attacked that town in 1668. Woodward was freed and, joining Searle's company, was taken to the Leeward Islands. Here he stayed until 1669, when a ship bound for London finally came into port. Again, he joined that ship's company, but, as luck would have it, this vessel was shipwrecked on the island of Nevis by the same storm that wrecked the *Albemarle*. Once again, Woodward was on a lonely Caribbean island until another vessel happened by.

Serendipitously, that ship was the *Carolina*. Woodward joined the expedition, once again heading back to the same land from which he had been so abruptly removed two years earlier. For the colonists, his unforeseen presence was a boon. Woodward had a knowledge of the land and the natives who lived there that none in their party possessed. As the infant colony struggled that first year, his experience would prove invaluable.

On with the story of the *Carolina* and the other ships in the fleet. They sailed from Nevis, only to encounter another fierce storm, this one separating the vessels. After wandering for six weeks, lost and without water, the *Port Royal* wrecked in the Bahamas in yet another storm. The crew and all thirty-six passengers were able to get to shore, but many died before the captain could build a new vessel. The *Three Brothers* was blown far off course by the storm and, although they eventually made landfall in Virginia, it was months before they were heard of. The *Carolina* eventually limped into Bermuda, an unintended stop. This accidental stopover again proved providential for the new colony, for here the elderly but wise Colonel William Sayle joined the expedition as the colony's first governor.

Finally, in March 1670—almost nine grueling months after its departure from England—the *Carolina* made landfall at Bull's Bay, just north of present-day Charleston. Their welcoming party was a band of Sewee Indians, probably a hunting party taking advantage of the plentiful game on the barrier island they called Onesicau, later to become known as Bull's Island. "Bony conraro angles!" the Sewee shouted in the fractured language they had learned from the Spanish; "Welcome, good friends, Englishmen!"

The Sewee's friendliness boded well, for the colonists had originally intended to locate their settlement at Port Royal. But the Sewee and their distant neighbors, the Kiawah, explained the vulnerability of that region; not only was it in close proximity to the Spanish at St. Augustine, there was also a warring tribe in the region called the Westo. The colonists were thus persuaded to establish their new colony beside a Kiawah village on the banks of the Ashley River, naming their settlement Albemarle Point.

How magical this new land must have seemed to those travel-weary settlers. Their arrival in mid-March coincided with the budding Lowcountry spring. They were seeing for the first time the colors and fragrances of the flowering trees and plants, enjoying the warm days and gentle breezes. They must have thought they had arrived in Eden. How amazed they must have been when, later that winter, a frost and layer of inch-thick ice destroyed their crops.

The colonists barely made it that first year. Provisions were so low that the weekly ration of food was in peas—five quarts for a man, four for a woman and three for a child under sixteen. Only with the help of the Kiawah and other neighboring tribes, and by rationing their food, did they stave off starvation.

Colonial life was harsh in other ways. The societal mix was made up of masters, their indentured servants (usually bound to service for seven years), wives and

children. Penalties for breaking the law were stringent and public floggings were common. An indentured servant named Dennis Mahoon received nine lashes on his bare back for trying to run away from his master in 1672. Thomas Sceman received nine lashes for stealing Henry Hughes's turkey cock.

They had also settled, in the words of colonist Joseph Dalton, "in the very chaps of the Spaniards." Consequently, they quickly had to learn the art of soldiering along with farming. In August 1670, a group of Spaniards from St. Augustine with allies in a neighboring Indian tribe made an attempt on the settlement. Again, it was through the colonist's friendship with the Kiawah Indians that this attack was thwarted and the Spaniards withdrew.

Despite the obstacles, the colonists were people with a focus toward the future, not the hardships of the present. By 1672, after the arrival of more ships with new settlers, there were 337 men, 71 women and 62 children living at Albemarle Point.

With each ensuing year, the colony grew in both population and prosperity. Finally in 1680 it was decided to move the town to the peninsula, then known as "White Point" for the spit of oyster shells that jutted out between the two rivers. The colonists named this new town "Charles Town" in honor of the British monarch, Charles II. Within decades Charles Town was so prosperous and sophisticated it was known as the "Little London" of America.

It has often been said that Charleston was founded by wealthy people who came to Carolina for opportunity. Indeed, some of the original colonists were of a class of nobility far more accustomed to the great halls of England than the log huts at Albemarle Point. Yet hardship and starvation know no social class. On equal footing they withstood and overcame the rigors those first years presented. They were the rich along with the tradesman, the farmer, the merchant and the servant. They not only survived, they eventually thrived.

# Walking Where the
# Red Man Walked

Night was approaching as we walked the bluff. Below us, out of sight, the narrow twists of Awendaw Creek flowed black with tannin from the swamps. My guide was Tim Penninger, a life-long resident of the Awendaw area and a man as familiar with the countryside as the Indians we were exploring. The sun had just settled beyond the trees and the green-swagged tops of longleaf pines and stark outlines of leaf-barren hickories were etched against a blazing western sky. In the afterglow, the evening clouds had been miraculously transformed into long, trailing wisps of vivid color—pink flushed with deep purple and bold swashes of cerulean blue. It was beautiful, looking to the west. Then we turned and looked east. In white, shining splendor, there was the rising full moon.

In any setting this dramatic celestial conjunction is powerful. Intense. But here, atop a broom-grassed knoll in deep woods, surrounded by silence except for the wind sighing through the tops of the pines, the effect was mystical. We were standing on what may have been the center of an ancient Sewee Indian village, viewing a sight which, perhaps, these long-lost people had watched in their own lifetime with the same spellbinding awe.

I tried to imagine what this present tangle of wilderness was like four hundred years ago. I could almost see the village, with its well-ordered community of small, circular dwellings roofed in pine bark, Spanish moss and palmetto. I could almost hear the bustling sounds of people preparing for the end of the day—the soft, busy murmur of women readying the evening meal; the robust voices of the hunters returning from the woods carrying their day's quarry of deer or wild turkey. There might have been the sounds of running, laughing children and the happy bark

of a dog chasing them in play. I could almost smell the scent of the wood smoke and the aroma of venison broth cooking in a clay pot over the fire. Perhaps the small, ochre-colored pottery shard I had found earlier had been from such a pot. It was now just a jagged, earthenware fragment, so worn from age that only the bare outlines remained of the intaglio design artfully applied when the pot was originally fired. Yet it was a connection—a tangible and touchable confirmation of a people who were the inhabitants of this land not so very long ago.

Ethnologists believe that about a dozen different Indian tribes lived along the Carolina coast at the time of the arrival of the white man, generally included in a group called the Cusabo. They're gone now. All that remains are the names they gave to the rivers and bays where they resided. South of Charleston harbor were the Edisto, Bohicket, Stono, Kiawah, Ashepoo, Combahee, and Wimbee. Along the Wando and Cooper rivers were the Etiwan and Wando. On the northern coast were the Santee and Winyah. And here, along the shores of the narrow watercourse we now know as Awendaw Creek, lived the Sewee.

It appears that they named the creek "Boowatt," for this is the name that appears on the earliest maps of South Carolina. Later, this slender tidal creek became rather grandiosely known as "Sewee River." Only in more recent times did it evolve to its present title, Awendaw Creek, which, for most of us, goes all but unnoticed as we speed across its bridge on Highway 17 driving toward McClellanville. But to the Sewee, it was their river, and they lived, hunted and farmed corn, beans and melons along its shores.

Thus, when the first ship carrying English settlers to Carolina arrived at the north end of Bull's Island in 1670, it was the Sewee who greeted them. Nicholas Carteret was aboard the *Carolina* and later wrote of this first meeting: "Upon [the ship's] approach . . . the natives . . . upon the strand made fires and came towards us whooping in their own tone and manner, making signs also where we should best land . . . when we came ashoare they stroaked us on the shoulders with their hands, saying Bony Conrary Angles, knowing us to be English by our collours (as we supposed). We then gave them brass rings and tobacco, at which they seemed well pleased. . . . They liked our company soe well that they would have come aboard with us."

Several days later the colonists visited a Sewee village. Carteret continued:

*As we drew to the shore a good number of Indians appeared, clad with deare skins, having with them bows and arrows, but our Indians calling out Appada [their word for "peace"] they withdrew and lodged their bows and returning ran up to the middle in mire and water to carry us ashore, where, when we came, they gave us the stroaking complim't of the country and brought deare skins, some raw, some drest, to trade with us, for which we gave them knives, beads and tobacco and glad they were of the Market. By and by came their women clad in their Mosse roabs, bringing their pots to boyle a kind of thickening which they pound and made food of, and as they order it being dryed makes a pretty sort of bread. They brought also plenty of Hickery nutts, a*

*wallnut in shape and taste, only differing in the thickness of the shell and smallness of the kernel. The Governor [William Sayle] and severall others walking a little distance from the watter side came to the Hutt Pallace of his Majesty of the place, who meeting us took the Governor on his shoulders and carried him into the house in token of his chearful entertainment. Here we had nutts and root cakes such as their women useily make, as before, and watter to drink, for they use no other lickquor as I can learn in this countrey. While we were here, his Ma'tye's three daughters entered the Pallace all in new roabs of new Mosse, which they can never beholding to the taylor to trim up, with plenty of beads of divers collours about their necks. I could not imagine what the Savages would so well deport themselves, who coming in according to their age and all to salute the Stangers, stroaking of them.*

Was this the same place I stood watching the setting sun and the rising moon? At Awendaw?

Explorer John Lawson gave the first historical mention of Awendaw by name when he journeyed through the area in 1700. "On Thursday Morning we left Bull's Island," he wrote, "and went thro' the Creeks, which lie between the Bay and the main Land. At Noon we went on Shore, and got our Dinner near a Plantation on a Creek having a full Prospect of Seewee Bay: We sent up to the House, but found none at Home, but a Negro, of whom our Messenger purchase'd some small Quantity of Tobacco and Rice. We came to a deserted Indian Residence, call'd Avendaughbough, where we rested that Night."

More than likely, the "plantation" Lawson visited was Salt Hope, a 600-acre tract of land on the south side of Awendaw Creek that had been granted to Governor Nathaniel Johnson in 1696. Later, Johnson acquired another seaside grant called Salt Ponds and, by 1709, his holdings had grown to over 12,000 acres known as Sewee Barony. It is an interesting question as to why Lawson came upon a deserted village, not an inhabited one. Whatever the reason, from this point onward, the lands of the Sewee became more and more under the control of the white man. Eventually, the friendly and once robust Sewee, who Lawson praised for their physical strength, courage and indefatigable hunting abilities, were no more.

But for one brief moment, on a remote wooded bluff where the only recent sign of habitation was where the broom grass had been flattened by sleeping deer the night before, the Sewee were remembered. With a setting sun championed by a rising moon; Awendaw became Boowatt once more.

# Spanish Moss

"SPANISH MOSS, HANGIN' DOWN, KEEPS on followin' my thoughts around." So sang musician Gordon Lightfoot about Savannah and Spanish moss. Savannah poet Sidney Lanier wrote of the "glooms of the live oak, beautiful, braided and woven." Indeed, nothing says "Lowcountry" quite like Spanish moss.

Yet there is more to the story of Spanish moss than told by poets and songwriters. The horsehair stuffing in grandmother's antique ottoman? It actually may be Spanish moss. The saddle blanket carried by the Confederate soldier at Gettysburg? It, too, may have been woven from Spanish moss.

In fact, this quintessential Southern plant has seen a score of different uses throughout history. Spanish moss has been used to feed livestock, as stuffing for mattresses and furniture, as packing material, mulch for gardens and mixed with mortar to strengthen construction. It has been brewed into a tea to relieve such ailments as rheumatism and diabetes. It has even been used to make a type of cloth.

For almost three hundred years, until the advent of synthetics, there was a ready international market for Spanish moss. "Moss pickers" harvested, ginned and baled Spanish moss just as they did cotton. A German visitor to South Carolina in 1825 noted that local merchants were exporting the "Spanish beard" to mattress makers in Europe. In 1939, over 10,000 tons of Spanish moss were cured and ginned, bringing $2.5 million into the Depression-poor South.

Spanish moss may be called moss and generally accepted as moss, but it isn't a true moss at all. The scientific name is *Tillandsia usneoides* (which, roughly translated, means "looks like moss"), and it is defined as an epiphyte or air plant

that has no roots but delicately entwines itself around tree branches with long, thin stems. Contrary to popular thought, it is not a parasite that eventually kills the trees on which it resides. It is a bromeliad, first cousin to the pineapple, and a flowering plant.

As such, it has leaves (the grayish-green part of the plant we see), which are covered with tiny scale-like cups that catch moisture and nutrients from the air. The plant even produces a bloom—a tiny, pale bluish-green flower that emanates a light, sweet fragrance on summer nights. This bloom forms a small fruit that eventually splits open to release seeds that are dispersed by wind and birds.

The substance that lies beneath the gray-green outer covering is what made Spanish moss a significant commodity of the American South. The central core of each strand is a long, black, extremely resilient fiber about the same consistency and strength of horsehair. Separated from the plant through a cleaning, curing and ginning process, this thread-like material was once marketed in huge quantities as upholstery stuffing.

The popular story of Henry Ford using Spanish moss to stuff the seats in his Model T's is probably true. However, the story of chiggers in the moss causing the first automobile "recall" is just that—a good story. During curing, the moss was thoroughly cleaned, soaked in water for two months, air dried in a "moss yard" and run through a mechanical gin. Any creature would have been dispatched long before the moss was riding the open road.

Early colonists were surprised to find that, aside from animal skins, the native coastal inhabitants wore clothing made with a cloth-like material woven from "tree hair," the name they gave to Spanish moss.

One early Spanish missionary described women wearing a tunic that they made from "the pearl-colored foliage of the trees." In 1670, an English colonist at Charles Town noted that the native women were dressed in new moss "robes" which they were "never beholding" to a tailor for sewing up.

The coastal Indians were characteristically creative in their widespread use of this natural product. Extremely absorbent (Spanish moss can absorb water up to ten times its dry weight), moss was used to plug crevices in their bark-made huts and as a summertime roof covering that allowed fresh air in and provided shade. Learning from the Indians, the early colonists mixed moss with mud to make an incredibly strong mortar for building construction.

Of all the creative uses the Indians had for Spanish moss, the most surprising may be its use as a type of baby diaper.

In 1700, explorer John Lawson described the Indian practice of making a "cradle" for a newborn, a papoose-like carrier designed to be worn on the mother's back. Basically, the carrier was a two-by-two-foot board fastened to a second board on which the child sat strapped in. Ingeniously, under this bottom board the Indians would "put a Wad of Moss," wrote Lawson, "that receives the Child's Excrements, by which means they can shift the Moss, and keep all clean and sweet."

Of the many shortages in the South during the Civil War, one critical need was blankets. Wool had to be brought in through the blockade. Enter the horsehair-like inner strand of Spanish moss. When tightly woven, moss could be sewn into a serviceable, water resistant blanket. Soon, Spanish moss suppliers and weavers in Alabama and Georgia were providing the Confederate government with moss saddle blankets along with other moss-made necessities including artillery mats, saddle horns and horse collars, referred to in Confederate records as "moss collars."

While records are scant, recent findings show that the moss-woven saddle blankets measured approximately 40 by 60 inches and were hand-braided in four different weave patterns. As the war continued, Confederate soldiers in the field were eventually forced to use these moss blankets in absence of woolen ones. While they were scratchier than wool, they kept the soldiers warm and dry, for the moss blankets were almost completely waterproof. In Macon, Georgia, more than 8,000 moss blankets were issued between June 1863, and February 1864, alone.

Native Americans called Spanish moss "tree hair." Early writings described it as "long moss." French explorers dubbed it "Spanish beard" as a derogatory slur against the Spanish, who returned the insult by calling it "French beard." During its peak use as upholstery stuffing, it became known as "black moss," for the natural dark color of the moss's central filament. Perhaps the most descriptive name is "gray beard." Of all these various terms, the term "Spanish moss" survived.

While it is no longer marketed by the ton as an upholstery stuffing, packaged Spanish moss is still sold commercially on an international scale, particularly to floral designers and arts and crafts concerns as a decorative item. With two cubic feet of cured moss selling for an average of between $12 and $15, one sees why local handicraftsmen have discovered an easy way to "cure" moss at home—they either boil and then dry it, or briefly zap it in the microwave. Always inspect the moss before you bring it inside. All sorts of creatures call it home, from frogs to birds. The usual suspect, however—the chigger—generally only attaches itself to moss after it has fallen on the ground.

Spanish moss is ubiquitous, beautiful and thoroughly and indisputably Southern. It brings a haunting beauty to our streets and roadways. It is a visual metaphor for the South. Writer James J. Kilpatrick may have described it best: "An indigenous, indestructible part of the Southern character; it blurs, conceals, softens and wraps the hard limbs of hard times in a fringed shawl." When a Southerner looks up and sees Spanish moss hanging from the trees, he knows he's home.

# Confessions of a Hurricane Watcher

THE TELEVISION IS TUNED TO "Tropical Update." The computer is on-line, connected to the Caribbean Hurricane Network.

Call me Wind Woman. Call me overzealous prognosticator of gloom and doom. Call me a weather-watching fool. Come September, my eyes search the sky for clouds called "mare's tails" and I'm alert to the slightest puff of wind from the east. I can't help it! I am shamelessly addicted to hurricane watching.

How did I get this fascination with a natural power that experts describe as the most destructive on earth? My attraction to storm watching probably started with my father teaching me, before I could write my name, to track a hurricane on a map. Or listening spellbound to Edisto Islander Chalmers Murray as he told tales of killer storms that swept entire houses out to sea with their helpless occupants inside.

I spent much of my early childhood at the Murray's place on Edisto. Here on the island, Edward Simmons, a Gullah fisherman and Murray's lifelong friend, taught me my first lessons in how to listen to the wind and read the skies. I was six. Edward, by his own admission, was either sixty or eighty. We were a pair—tall, black, weatherworn Edward and small, tow-headed me—as we fished the tidal creeks in his ancient bateau. "Watch-em for mare's tail," he would advise in the speech of the old-time Gullah people. "Mare's tail in sky mean storm in two." That meant two days.

Edward's meteorological knowledge was born from first-hand experience. He had survived the Great August Cyclone of 1893 as well as the equally severe hurricanes of 1911, 1928, 1940 and 1945. Edward's mare's tails are no backwoods

fable, but the long sweeping cirrus clouds formed by the leading edge of a storm. When they fill the sky during September, a hurricane is out there somewhere, churning up the seas.

The Chicken Little element of my psyche likely hatched when I was in the first grade, when Hurricane Hazel hit Myrtle Beach dead-on on October 15, 1954. Hazel was a real witch, "extreme" in hurricane parlance. Her winds and waters rearranged both beach and buildings with shrewish intent. Charleston was minimally affected, but the news photos of Hazel's awful destruction on the upper coast seared into my memory.

When Hurricane Gracie roared ashore on September 29, 1959, the pictures became reality. Although my parents decided to ride out the storm at our house on Sullivan's Island, I was "evacuated" to family in town and supposedly safer ground. Hah! My safe house was at East Bay and Water Street overlooking High Battery. At the height of the storm, huge waves crashed against the sea wall, then slammed into the house, breaking even the fourth story windows, closed shutters be damned. My memories are of fear, then of work, as we spent a harrowing night moving furniture away from blown-out windows and mopping rain-soaked floors. The aptly named Water Street reverted to its original state, a creek. Even after the storm had passed, the water was to my waist. It was the first time I saw wharf rats swim.

The rats swam again during Hurricane David on September 4, 1979. Like later Hurricane Floyd, David was a big bad wolf that had blown out most of its bluster by the time it hit Charleston. Yet thigh-deep water still swirled outside my house downtown. And since David hit during the day, I actually got to watch as the wind, with sardine can ease, peeled off the roof from the house across the street.

And then there was Hugo. Huge, horrible, horrendous Hugo. A small storm is exciting. There is a certain exhilaration in witnessing, at least in modest doses, the raw magnificence of nature's power. Charlestonians don't historically leave at the approach of a hurricane and I stayed for Hugo. None of my previous hurricane experiences prepared me for the magnitude of this colossal storm.

The sounds this monster made are what I remember most. They began hours before the storm hit when, even from my yard in Mount Pleasant's old village, I could hear the waves thundering ashore on Sullivan's Island. Then came the freight train from the east, hauling the roaring gales that made trees groan, bend and eventually snap. Even the house took voice, and shuddered and moaned with every crushing gust. There was the gnashing screech of flying tin, sizzling St. Elmo's fire and staccato pops of lightning. Above this wild cacophony, high in the sky, the whining scream of the storm's worst fury sounded like a Ferrari P-4 on a never-ending stretch. It was terrifying.

So I confess. I am an unrepentant hurricane watcher. In these parts, September is the cruelest month. Thus, I keep my eyes to the sky. You can laugh. You can even call me Wind Woman. But beware. Mare's tails don't lie.

# Gullah and the
# Sierra Leone Connection

ONE OF THE LOWCOUNTRY'S STRONGEST links to the African country of Sierra Leone is the kinship of language. In Sierra Leone, they speak a language called Krio, which has striking similarities to Gullah, the language long spoken by the coastal sea island black population.

Both are what linguists call English-based Creole languages, hybrids that blend linguistic influences from a variety of different sources. They are not "broken" English, but recognized languages with true grammatical structures. Both hearken back to the days of slave trading and hold a creative mix of African and English words spoken in sentence patterns that strongly reflect African origins.

For instance: In English, the name for a human female is "woman." In Gullah, the word is *ooman*. In Krio, the word is *uman*. Neither *ooman* nor *uman* are of African origin but the word is spoken with the pitch, stress and intonations of the African tongue.

Conversely, the word for a baby chicken in America is "biddy." In Gullah and Krio, the word is also *biddy*. Yet in this instance the source is African, from the Kongo word, *bidibidi*, which means "bird."

One of the world's top authorities on the Gullah/Krio connection is Dr. Joseph Opala, an anthropologist and research fellow at the Gilder Lehrman Center for the Study of Slavery, Resistance, and Abolition at Yale University. Opala lived in Sierra Leone for twenty-three years where he was a lecturer at Fourah Bay College (University of Sierra Leone), at which time he established the Gullah Research Committee.

Opala explains that both Gullah and Krio originated in the days of the slave trade when almost the entire West African coast was studded with slave trading stations. In order to communicate with the English traders (and with each other), the Africans invented a type of pidgin English. This Creole (thus the name Krio) became the lingua franca of the slave trade and, eventually, Sierra Leone. It was then imported into the Americas with the slaves, becoming the language we know today as Gullah.

The exact origin of the word *gullah* (pronounced in the Lowcountry as "gull-uh"; in Sierra Leone as "goo-luh"), is unknown. It may be a shortened form of Angola or, possibly, named for the Gola, a tribe in Sierra Leone. Opala also believes the term Geechie, a term often used interchangeably with Gullah, may have African roots as well, possibly named for a Sierra Leonean tribe, the Kissi, which they pronounce as "Geezee."

Newcomers and visitors to the Lowcountry may find it difficult to believe that only a few decades ago the resort islands of Kiawah, Seabrook and Hilton Head were remote hinterlands. Roads were few and unpaved; bridges were either one-lane archaic wooden structures or nonexistent. The main mode of transportation was the horse- or mule-drawn cart. There were few telephones and it was rare to find a home with electricity. The people who lived in these remote regions were the descendants of slaves. Until the early 1960s, they were living in a state of suspended time. The twentieth century may have come to the rest of the world, but not to the coastal sea islands. Thus, many Africanisms in culture and custom remained, especially the language called Gullah.

Then came progress. As one Gullah resident from Edisto commented, sadly shaking his head, "everyt'ing change-up now." The old ways began to disappear with every new road and bridge. In some cases, such as education, the changes were good. But Gullah, the native tongue spoken so long by the black majority, began to disappear. For many young, educated black men and women, the language came to signify ignorance and poverty. The fact that it represented a direct connection to their African roots was largely overlooked.

Thankfully, these attitudes have changed. Gullah no longer merits an apology but serious study as a true language, one to be examined and explored and, certainly, one that provides a direct link to the historical and sociological events that helped shape the foundations of Lowcountry culture.

This connection in language is far-reaching and not limited merely to those of African heritage. For instance, the Krio word for "boy" is *bohboh*. In Gullah, it is *buhbuh*. How widespread the word "bubba" has become. For those of you who grew up calling your grandmother "Nana," that particular word has a direct African source. The word for "mother" used by the Temne, another Sierra Leonean tribe, is Na.

The study and preservation of Gullah is more than mere linguistics. On both sides of the Atlantic, the questions of "who are my people in Africa?" countered

by "where did our people go?" have been unanswered for far too long. Gullah is an important and tangible representation of the long-lost connection between African and African-American kinsmen.

The ties between Sierra Leone and coastal Georgia and South Carolina are significant and enduring. The study of this connection is young and much more remains to be learned. Every new linguistic, historical and archaeological discovery brings forth a knowledge that enables us to reach back into an important section of history and learn. It begins to provide answers that help regain—and repair— three centuries of separation. It opens a window into the past, allowing people from both places to say, with hope:

"I know where my people may have come from."

"I know where my people may have gone."

# Learning From Buster

BUSTER IS BACK AND HE is heralding his arrival in archetypal catness: he is howling. Buster is a dull-furred, caramel-colored, ear-chewed male cat who says he lives with me. Buster is not my cat. Buster wants to be my cat. I have told him, over and over again, that I already have three cats and that's a fur-full. Also, with the recent arrival of one black Labrador puppy who, at four months is already close to fifty pounds, this particular Animal Inn is closed. Buster won't listen. I'm fairly certain Buster belongs to someone who lives in the neighborhood. Buster, however, prefers life with me.

As I write this (at 9 a.m. in the morning), Buster is serenading his undying love for me, my other cats (fixed females), my dog and all the good fortunes of his joyous cat life. This is done in deep-throated, raspy, unceasing "MURRROWWS" that are loud enough to wake the dead and certainly enough to awaken me at three o'clock in the morning when he repeats his vows of love and adoration outside my bedroom window. Telling him to be quiet does no good. Buster is vocal. Buster is operatic. Buster, it seems, cannot walk one paw length without announcing this success to the world in loud, proud yowls.

Buster is what folks down here call a "Bull Cat." He is male and extraordinarily proud of each and every scar on his fat-cheeked jowls. He is dirty and smells bad, an aroma he considers sweet perfume, a stench he feels compelled to spray onto every available surface. Buster is not allowed inside, a fact which does not deter him one iota. He sneaks into the kitchen whenever possible, grabs a snack from the cat bowl and then thanks me by leaving behind his undeniable scent. It is the more noxious side of having Buster take up residence within our otherwise aroma-free

domain. The kitchen either smells like Eau de Buster or Pine-Sol and too much of either is enough to gag a zookeeper. So far, Buster has been chased with a broom, soaked with a pot of water and hit with a shoe. All such endeavors have proved fruitless. Buster loves me. Buster loves my cats. Buster loves my dog. Heck, Buster loves LIFE!

I find it odd that the other cats, who are all dainty females and clean to the point of antiseptic, actually *like* Buster. Even the puppy likes Buster. I suppose I could learn to like Buster if there were a way to do something about his late-night singing and his redolent compulsion to spray the world.

Of course, if Buster were my cat, I could have certain parts of Buster removed and that might do the trick. But Buster is not my cat. Buster just thinks he is.

Besides, howls Buster, "It is SPRING! Life is GOOD! The birds are singing and SO AM I! MURROWWW!" he croons in full-throated splendor. "Wake up world! I am BUSTER! I am PERFECT! I am CAT! MURRROWWW!"

He has a point. Life is good and this spring is particularly gorgeous. Our already beautiful town is even lovelier with this year's spectacular bloom. The sun rises each morning to the cheerful songs of spring-awakened birds and, each night, the sun sets to the pulse of a shimmering Mars on the horizon, with a comet adding a touch of natural artistry.

Yes, Buster is right. There is, indeed, something to howl about. I suppose the best I can do about Buster is to learn to live with his screeching librettos and buy more bottles of Pine-Sol. For deep beneath Buster's dull, dirty, matted yellow fur, behind his war-torn ears and obnoxious odor, there exists a happy, life-loving creature with a full appreciation for all the blessings of his wonderful existence.

So to my neighbors, my apologies for the midnight serenades and please understand, Buster isn't my cat. He just thinks he is. He talks too much and he smells. Consider him a sort of furry town crier with a positive message sung in off-keyed joy. When you hear the discordant yowl of Buster on the prowl, remember what he caterwauls.

"Wake UP world! Spring is HERE! I am BUSTER! Life is GOOD! MURRROWWW!"

# Bahai de Cayagua

BAHAI DE CAYAGUA. DOESN'T THE name evoke images of a romantic, sun-drenched resort in Mexico or the Caribbean? Can't you just see the swaying coconut palms and the endless white beach fronting an azure sea?

Had the early Spanish explorers been ultimately successful in claiming the Carolinas for Spain, this exotic sounding name would be the place we called home. For this was the name the Spanish gave to what we now know as Charleston Harbor. Bahai de Cayagua—Kiawah Bay. The name came from the Spanish interpretation of the river the Indians called "Kiawah." We now know this river as the Ashley.

Although the English were the first to permanently settle here in 1670, the Spanish had been on Carolina soil a full century and a half earlier. In 1526, Lucas Vasquez de Allyon attempted a settlement at Port Royal near Beaufort. In 1563, Pedro Menendez established another post in that region called Santa Elena (St. Helena). Although these attempts at colonization were unsuccessful, St. Helena and parts of the lower coast continued to be variously occupied by groups of Spanish soldiers.

Indeed, the Spaniards were here early, and first. It is only because of their somewhat pushy methods (there's an understatement), that they did not gain more of a stronghold in South Carolina.

Case in Point: In 1569, a Spanish missionary named Juan Rogel arrived on Edisto Island where he attempted to convert the "heathens" of the place he called Orista. For two years he lived among the Edisto Indians with three Spanish boys who were to learn the language of the Indians. He built a church and a house overlooking the South Edisto River at a place he named Saint Pierre's Point.

"In the beginning of my relations with them," Rogel wrote of the Edisto Indians in 1570, "they grew very much in my eyes, for seeing them in their customs an order of life far superior to those of Carlos [in Florida], I lauded God, seeing such Indian married to only one woman, taking care of and cultivate his land, maintain his house and educate his children with great care . . . not contaminated by the most abominable of sins, not incestuous, not cruel, nor thieves, seeing them speak the truth with each other, and enjoy much peace and righteousness."

A year later, Rogel was of a different mind. It is doubtful that he was successful in obtaining many converts. He later wrote that one main cause of his failure was that when he began to preach against the devil, the Indians became highly offended. They presumably felt that an attack had been made on one of their own deities. Rogel had also attempted to convince them that their mode of dress (both the men and women went bare-chested) was wrong in the eyes of God. That winter, when the Indians moved into the woods to search for food, Rogel tried to follow. They made it clear he was unwelcome.

Rogel was probably a good man. The Spanish soldiers at Saint Elena, however, treated the Indians with less respect and often with cruelty. Their methods were supported by muzzleloaders; they were conquistadors searching for gold and silver instead of peaceful colonization. It did not take long for the Indians to respond in kind.

Even had Rogel been successful with his efforts, his progress would have been destroyed by the conduct of the Spanish soldiers. First, a captain, Hernando de Miranda, arbitrarily killed two Indians apparently without sufficient cause. One was a chief named Hemalo, who had actually visited Madrid.

Shortly thereafter, when the soldiers at Saint Elena were suffering a shortage of food, twenty-two Spanish soldiers were sent to an Indian village to procure some by force. The Indians, now clever to the Spanish ways, persuaded the captain to have his men extinguish the matches with which their guns were fired, saying that the women and children were afraid they were going to be killed. As soon as the Spanish soldiers had done so, the Indians fell upon them, killing all but one man who presumably escaped to tell the tale. Later, 2,000 Indians besieged the fort at Saint Elena and the Spaniards withdrew to Saint Augustine. Needless to say, Father Rogel withdrew also, but the site where he lived on Edisto still remains, the name now anglicized to "Peter's Point."

Even after the English settlement at Charles Town, the Spaniards continued to harass the lower Carolinas. Although there was no Spanish post east of the Savannah River, they often engaged the help of a warring Indian tribe from the Savannah River region, the Westoes. There were also serious attempts at invading the colony from the sea. One such attempt was made in 1686, but was thwarted when a sudden storm hit on September 4, driving away the fleet. This storm eventually became known as the Spanish Repulse Hurricane, possibly the first "named" hurricane in South Carolina history.

In August 1706, a fleet made up of both Spanish and French soldiers, with 200 Indians allied to the Spanish, attempted another coastal attack. Called the French-Spanish Invasion, it actually resulted in armed conflict, with skirmishes taking place both on the East Cooper side of the harbor and on James Island. The colonial militia, with the help of friendly Indians, thoroughly trounced the invaders, killing some thirty to forty of the enemy. This was the last formal attempt the Spanish made at taking the colony at Charles Town.

The Spanish influence on words and place names still remain, however. Beautiful Cape Romain was the Capo de Romano of Spanish explorers of the early 1500s. The resort at Edisto Island recalls the Spanish name for the island, Orista. Even our word for cooking outdoors, barbecue, hearkens to Spanish antecedents and is the Spanish form of the Carib Indian word *barbacoa*.

Had the fortunes of war played on the side of the Spaniards at St. Augustine, we might now be living alongside the beautiful Bahai de Cayagua. I wonder how that would sound in Charlestonese?

# They Call It "Jim Isle"

Part residential, part farmland—part green, expansive marshland and part oyster banks and pluff mud—that's James Island. Or, as the locals proudly say, "I be from Jim Isle."

Bounded by the Stono River on the west, Wappoo Creek on the north, the harbor on the east and miles of marshlands and tidal creeks on its southern shores, James Island's history begins with the first English settlement at Albemarle Point in 1670. It seems likely that the island was named for James, Duke of York, the future James II of England.

One of the earliest (if not the earliest) records of the island appears in the *Journals of the Grand Council* on September 5, 1671. It was ordered that thirty acres of land be laid out "Southward from Stonoe Creeke for a Towne for the settling of those persons who lately arrived from New Yorke in the Shipps Blessing and Phoenex which said Towne shall be called and knowne by the name of James Towne." Also referred to as "New Town," this small settlement apparently had a short life and no records of it appear after 1672. However, the name James Towne stuck, except for a short period in the 1690s when the island was called "Boone's Island" for Governor Thomas Boone, who then resided on the island.

The earliest inhabitants of James Island were, of course, the Indians, most probably those of the Kiawah and Stono tribes. Certainly, the island's dense forests and surrounding watercourses provided ample food and a good way of life for these early inhabitants. Such bounty was equally attractive to those who followed and, after the arrival of the Europeans, the island was one of the first to be settled through large land grants.

By the early 1700s, the island was fairly well populated and the Herman Moll map of 1715 shows fifteen landowners on James Island. There may have been more, certainly enough that a law was passed in 1717 for the "Making a Road from Mr. Richard Woodward 's plantation on James Island to the plantation of Mr. Richard Godfrey, and building a bridge over Wappoo Creek."

James Island's history is an interesting mix of agriculture, shipbuilding and exciting military episodes. James Island farms have long been celebrated for their produce and only until very recently has the complexion of the island changed from agrarian to residential. Parts of the island are still farmed today, although they pale in comparison to the glory days of the once-great plantations. In the 1700s, many island fields grew indigo, a plant from which a blue dye could be extracted and which became a mainstay of the Carolina trade. More than likely, rice farming was attempted on the island, although probably not to any great extent. What the island was most famous for was cotton. Until well into the twentieth century, James Island fields were famed for their production of fine sea-island cotton. A living reminder of this previous eminence is the McLeod Plantation with its avenue of oaks, slave street and field.

The 1700s saw the island as a shipbuilding center. The Ship Registers in the South Carolina Archives show quite a number of James Island-built vessels— the *Betsy and Nancy*, a 16-ton schooner built in 1772; the 18-ton schooner *Blakeney*, built in 1757; the 30-ton schooner *Chance*, built in 1752; and several ships which shared the name *Charming Betsy*—to name only a few of the many snows, schooners and other sailing vessels built on James Island shores with oak from James Island forests. The island's strategic location between the harbor and the Stono River has given James Island an unusually important status in military history. Although Fort Johnson (built in 1708) is thought to be the earliest fortification in the Charleston area, one bit of correspondence may open the possibility of an even earlier fort on the island. In 1696, Elder William Pratt, the founder of the town of Dorchester, visited the island, noting: "the 6th of february we went over the water to mr. revers [Rivers] and from thence to mr. wm. Russels and 7th day of the month we travel'd about James's island as it is called and saw a place wher ther seemed to have been a fort made . . . and the walls about it was made with oystershels and earth."

A fort? Maybe. It may have been that Pratt was simply seeing a shell ring for the first time, a circular mound of oyster shells constructed by earlier Indian inhabitants. In 1802, historian John Drayton described a "mound of oyster shells, about one mile and an half south of Fort Johnson, on James Island," located on lands held by the Rivers family. This likely was the same edifice Pratt had seen a century earlier. "It is of circular form," wrote Drayton, "measuring around two hundred and forty paces. Its width at the top is ten paces; and at its base from sixteen to twenty; and its height is from eight to ten feet . . . It is situated in the midst of cleared lands, on no uncommon rising;

now surrounding the dwelling house and offices of a gentleman who resides on the island." Drayton also noted that this shell ring had been reduced by many feet for the purpose of burning lime, some of which was used in building St. Michael's Church in Charleston.

The island was active throughout the Revolutionary War and it was here, at Fort Johnson, that the first stamped paper arrived in 1765 following the Stamp Act. For most of that war, the island was in the possession of American troops. In early 1780, however, Sir Henry Clinton landed a sizable force on the island and, in March of that year, the startled citizens of Charleston awoke to see a British battery erected near Plum Island (now the site of the sewage treatment facility), their guns trained directly on the town. Charleston fell to the British shortly thereafter.

Undoubtedly, James Island's most vigorous military presence was during the Civil War. The actual "first shot" of this conflict came at 4:00 a.m. on April 12, 1861, when the action against Fort Sumter was opened by a shell from Fort Johnson on James Island. For four years, James Island was virtually an armed camp. The Confederates erected a battery, redoubt or breastwork at every major creek, bay, river or point of land on the island.

On June 16, 1862, the summering community of Secessionville on James Island became the scene of a major battle when Union troops under Brigadier General H.W. Benham, commanding three divisions of approximately 7,000 men, assaulted the island. The Confederate works at Secessionville were garrisoned by 750 men under the command of Colonel T.G. Lamar. The Union troops met with a disastrous repulse, losing nearly 700 men. The Confederate loss was 104 men.

In August 1863, a Union battery opened fire on civilians in Charleston with an 8-inch Parrott rifle from Black Island, situated in the marshes between James Island and Folly Island. Called the "Swamp Angel" it eventually burst, but only after inflicting serious damage to the lower peninsula. It was also at James Island that some of the last action of the Civil War in the Lowcountry took place, as Union troops moved in to take Charleston just prior to the city's evacuation in February 1865.

In 1826, Robert Mills described the island as ranging "the whole extent of the harbor, clothed with forested trees which are in perpetual verdure, and skirted in front with several handsome country seats." Some of the island still retains this character; sadly, much of it does not. In many ways, James Island represents the best and the worst of modern expansion. Today there is all too much of driving down the road, pointing to yet another shopping center or strip mall and saying, "remember what it looked like before?"

What tomorrow holds for James Island is unknown. The island has, however, a remarkable history, a past which should be remembered and respected. The island's remaining historical sites should be kept intact and undiminished by

the requirements of modern growth. Whatever else, let us hope that the future is one where we have put a reasonable check on the number of times we say "remember when" and, instead, proudly point to an historical site and simply say, "Remember."

# May

*This was written in May 1999, when our troops were assisting those fighting for freedom in Kosovo. The message is perhaps as meaningful now as it was then.*

COOL NIGHTS. WARM DAYS. THE songs of a hundred birds celebrating life. This is May, the most delicious month of the Lowcountry year. Flowers are blooming. Pollen is disappearing. The final oak leaf has fallen and the grass is greening out.

May is fresh, windblown air carrying the heady fragrance of star jasmine and freshly mown grass. It is pansies giving way to petunias. A time when the smell of wood smoke is replaced by the tempting aroma of a steak sizzling on a backyard grill.

May is blameless. A child without inhibitions who has kicked off the brown suedes and run barefoot on the beach. It is Mother Nature cleaning out her closet, discarding the old and drab for the new and colorful. Ditches and dunes are covered with bright yellow black-eyed susans and elegant stalks of lavender spiderwort. Magnolias hang seductively from glossy-leafed limbs. The sky seems bluer. The grass a luxuriant green. This is May.

May is the door opening to summer, a gentle buffer that allows us to slide unwittingly from sweater season to the hot-air blast furnace of July. A time when we open the minds and windows and let healthy breezes blow in. A time of renewal; of emergence. When faith is not only visible, but tangible as we watch seeds sprout and grow into healthy, vigorous plants.

As I write this, the sun is momentarily blocked by a C-141 flying overhead and the song of the mockingbird is replaced by the roar of jet engines. I shudder and remember: it is also May in Kosovo.

There, as spring is emerging on fields and mountains, as the first hints of new growth are showing in city garden plots, bombs are falling. People—not so very different from you and me—are fleeing to foreign borders for their lives. Kosovar children are experiencing first-hand the horrors we Americans worry that our children are assimilating through violent video games. Political beliefs aside, it is war. And as such, it is living hell.

How lucky we are, I think, here in this beautiful part of the world, living such easy lives. How casually we accept the simple freedoms so ingrained in our democratic society. How petty our problems appear as we whimper and whine about broken disposal units or inadequate paychecks. We're alive. We haven't the slightest notion what it is like to leave family and pets behind and make a desperate run for a border and safety. To frantically search for lost relatives in refugee camps. To watch spring emerge amidst a reign of terror and mass murders.

Yet what can we do, we spoiled yet thoughtful Americans who are concerned about a hundred thousand strangers undergoing such tragedy and misery?

We can pray.

The British theologian, C.S. Lewis, once wrote that he often prayed while he was washing his teeth. What he was saying was that for prayer to be meaningful, it didn't have to be long-winded, forced or elaborate. Sometimes all it required was a simple thought.

As you enjoy this beautiful, God-given, delicious day in May, join me. Whether you call your God Buddha, Mohammed, Allah or Jehovah, join me in a prayer which is as simple as the utterance of a single word: Peace.

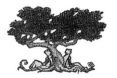

# Rice

"WHY ARE PEOPLE FROM CHARLESTON like the Chinese?" goes the old joke. The answer? "Because they worship their ancestors, speak a foreign language and eat rice."

One thing that often surprises visitors and newcomers to the area is finding rice so prevalent in Lowcountry cuisine. There is white rice, red rice and dirty rice. We have rice for lunch, rice for dinner and, for dessert, there is rice pudding. I happen to know one native Charlestonian who even forsakes grits and has rice at breakfast with his sausage and eggs. For some Lowcountry natives, a day is not complete without a serving of rice.

I think the most dramatic example I've ever encountered of this unusual daily requirement for rice came when a family friend, an elderly gentleman with a Lowcountry lineage spanning three hundred years, took a trip to England. Upon his return, we asked him how he enjoyed the English cuisine. "Well," he replied, "we mostly ate in Chinese restaurants." They were the only places he could find that served rice.

Of course, rice is delicious and wonderfully versatile. But the Lowcountry's love affair with rice is more than simple culinary taste. Rice in South Carolina is history—major history. From the 1680s until the late 1800s, rice was the mainstay of the Carolina economy, the prince of all crops. No other single element played such an important role in the social and historical development of coastal South Carolina.

It is thought that rice was first introduced to South Carolina in 1685, when Captain John Thurber, the captain of a brigantine sailing from Madagascar, put

into Charleston. In thanks for the kindness he was shown here, he purportedly gave a bag of Madagascar rice seed to Dr. Henry Woodward, who, with others, test planted the rice. By 1700, there was more rice grown than there were ships to export it and "Carolina Gold Rice" was well on its way to international fame. In 1740 alone, over thirty million pounds of rice were exported from Lowcountry tideland plantations.

Since growing rice requires periodic flooding of the fields with fresh water, the Carolina coastal lowlands were ideal for the cultivation of this extraordinary grain. Our rivers turn from salt water to fresh not too far inland, yet they are still influenced by the tides. Accordingly, an ingenious system of dikes and sluice gates (called "trunks") was developed which used the rising and falling tides to allow water to flow in and out when necessary.

Still, rice farming was expensive, incredibly labor intensive and rife with potential disaster. Salt water from unusual tides or storms could wipe out a crop instantly. Even before growing could begin, it took years just to convert the swampy lowlands into fields ready for planting. Trees had to be cleared and the wetlands drained—all by hand. The fields were then divided into squares intersected by a system of canals and ditches to supply the needed flow of water, with each field encompassed by high earthen dikes.

Growing was a delicate process and harvesting had to be done quickly and adroitly. Because of the huge amount of labor required, an unprecedented number of slaves were imported from Africa in the early 1700s. They were brought in by the thousands, especially from Senegal, Gambia and Sierra Leone, the grain coast of West Africa where rice had been grown for centuries. Early planters were extremely astute in their choice of slaves and requested those specifically from this region. These planters didn't buy simple brawn; they bought expertise and they paid top dollar for it.

There were two planting periods—March 20 to April 10 and June 1 to June 10. (Planting was rarely done between middle April and late May because huge flocks of migrating birds could consume a field of newly planted seed in a day.) Planting began with hoeing the fields into trenches usually 4 inches wide and spaced 12 to 15 inches apart. The seed was then set.

Since water both promoted growth and helped kill weeds and insects, the fields were flooded and drained three times during the growing season. First came the "sprout flow," when the fields were flooded until the seeds sprouted, after which they were drained and meticulously hoed. Next followed the "stretch flow," with the fields flooded for about three weeks or until the rice was able to stand erect. When the tallest grain had reached finger length, the water was slackened gradually for about ten days until the field was dry.

The fields remained dry for approximately forty days and were hoed daily, each field hand assigned about one-half acre, the normal day's hoeing for a seasoned hand. Finally came the "harvest flow" and water covered the fields

at a constant depth for ten days to two weeks. Then the fields were gradually deepened, with more water allowed in every five to six days until the dikes were filled to capacity and the rice was fully mature.

The September harvest was done quickly and with necessary speed, for this was the start of the hurricane season. As the fields were drained, the hands stood ready to immediately jump in and cut the rice before the ripe stalks could tip into the muck and ruin the grain. With a tool called a rice hook, basically a small hand sickle, an accomplished field hand would grasp three rows of grain with his left hand while swinging the rice hook with his right. The cut grain was then tied into bundles and transported to the threshing yard. Here, the cut grain was separated from the stalks, either by hand or, later, by a mechanical thresher.

The rice was then taken to the winnowing house where the grain was separated from the chaff by a process called "fanning," where the grain was tossed high into the air on a wide, circular "fanner" basket made from local grasses. This was an entirely African invention and was a precursor to the popular "sweetgrass" baskets so popular today. Today, rice grown in Sierra Leone is still winnowed by hand with fanner baskets. Finally, the rice was pounded to remove the hulls, first by hand and later, after the invention of a steam-powered engine at a rice mill. It was then placed into barrels and ready for shipment.

The Civil War and several severe hurricanes in the late 1800s tolled the death knell for rice farming in South Carolina. One of the last of the great rice planters was David Doar from McClellanville. In 1936, he wrote: "In years to come, when all the present generation has gone, the stranger and the wayfarer—passing along these mighty rivers, seeing the great dikes and the innumerable canals and ditches large and small, the fields divided into various sizes, or perhaps, roaming amongst the piles of bricks, all that remains of the old homes, driving up the old avenues of oaks and magnolias which led to them—will muse and wonder what race of men dwelt here and what all these works meant in and near the swamps."

He foresaw the future, for today, most of the thousands of acres of rice fields have reverted back to their previous wild state. Driving through what is now the Francis Marion National Forest it is hard to believe that a century ago much of these wooded lands were wetlands of well-ordered rice fields. Behind the stands of loblolly and long-leaf pine were great plantations where rice brought incredible wealth to the Carolina economy.

In some ways, it still does. For it was rice that built the great homes, stately buildings and elegant gardens which now draw millions of tourists (and dollars) to the Lowcountry every year. They come to admire the beautiful interiors, where bedrooms hold tall, mahogany "rice beds" decorated with a sheaf of rice carved intricately into each bedpost. They come to buy the

sweetgrass baskets sold on the roadside and at the city market. They come to dine in our restaurants. And, when they pick up the menu, you can bet there's one thing they'll always find listed: rice.

# Indenture

*RUN AWAY FROM HIS EXCELLENCY, Robert Johnson, Esq., a white Servant Man, named John Saxon, a Stone-cutter by Trade, about 31 Years of Age, he is a middle sized Man with reddish Hair and Beard, and broke out in his Face. Whoever will bring the said Servant to his Excellency's House in Charlestown, shall be well rewarded. Be it at the Peril of any one to Harbour or conceal the abovesaid Servant, for they will be prosecuted as the Law directs.*

—From the South-Carolina Gazette
October 1732

Servitude and slavery—the unjust ownership of one human being by another. Discussion of these practices has most often been focused on African slavery. As such, one of America's most important classes of immigrants, the indentured servant, has been overlooked.

These were men, women and children—Irish, Scottish, English, German and Swiss—who were owned by someone else for the period of seven years. Some came willingly, their indenture the means by which they could escape the poverty or persecution of their homeland. Others were indentured through nothing short of kidnapping. These were people fate had not treated kindly—women who, by no fault of their own, become destitute or without family; unlucky young men who were shanghaied and put onto ships as servants or common seamen. Since there were no child labor laws in those times, their ranks included an alarming number of orphaned children. No matter what their background, these people were bound by law to the service of another, their master, for the period of their indenture.

The treatment of indentured servants depended entirely upon the personality of the master. Sometimes the system worked and, after the requisite period, the

servant was free to start out on his own. All too often, especially in the Caribbean colonies, indenture resulted in absolute slavery and lifelong servitude.

Indenture was a good idea in theory, a legal work agreement between two people designed to benefit both. A father with limited means might indenture a son to a tradesman for seven years, a silversmith, for instance, or a blacksmith. In this manner the boy could learn a vocation from which he would eventually earn a living wage. For a young man with slim hopes, say someone of a lower class without the benefit of education, indenture to a merchant or factor's office might be the only way out of a dead-end future. In this context, the concept of indenture was positive. It provided people with a way to transcend limited circumstances.

The manifest of the *Carolina*, the ship carrying the first settlers to Charles Town in 1670, listed almost two-thirds of its passengers as servants. Land in Carolina was then granted through the headright system, a plan that guaranteed a certain amount of land to every free man for each man, woman and child he brought into the colony. A few of those listed as servants were actually family members, "servant" only on paper as a way to obtain additional acreage. Most were not. Their indenture was their sole way of coming to the New World. And as the advertisement above clearly shows, the indentured servant, no matter the age, sex or ability, was the property of another.

This was no slight business and the laws were strict. In June 1672, three indentured servants belonging to colonist Affra Coming—Phillip Orrill, Michael Lovell and John Chambers—got into serious trouble for not abiding by the terms of their indenture. The punishment ordered by the Grand Council seems harsh now but was common in the 1670s. Phillip Orrill eventually received twenty-one lashes on his bare back for what the Council deemed "gross abuses & destructive practices."

John Esquemeling (pronounced Esk-amalen), who wrote one of the earliest and most celebrated books on piracy, arrived in the Caribbean in the 1660s as an indentured servant to the East India Company. His indenture amounted to nothing less than slavery. He wrote:

*The planters that inhabit the Caribbee Islands are rather worse and more cruel unto their servants than to their slaves. . . . In the Isle of Saint Christopher dwells one, whose name is Bettesa, very well known among the Dutch merchants, who has killed a hundred of his servants with blows and stripes. The English do the same with their servants. And the mildest cruelty they exercise towards them is that, when they have served six years of their time . . . they use them with such cruel hardship as forces them to beg of their masters to sell them unto others, although it be to begin another servitude of seven years, or at least three or four. I have known many who after this matter served fifteen and twenty years before they could obtain their freedom.*

Esquemeling was sold from one indenture to another on the island of Tortuga into the hands of a man he wrote as being, "the most cruel tyrant and perfidious man that ever was born of woman, who was then Governor, or rather Lieutenant-

General of that island." Esquemeling was treated barbarically "with all the hard usages imaginable," he wrote, "that of hunger, with which I thought to have perished inevitably. Withal he was willing to let me buy my freedom and liberty, but not under the rate of 300 pieces-of-eight, I not being master of one, at that time, in the whole world. At last through the manifold miseries I endured, as also affliction of mind, I was thrown into a dangerous fit of sickness. This misfortune, being added to the rest of my calamities, was the cause of my happiness. For my wicked master, seeing my condition began to fear lest he should lose his moneys with my life. Hereupon he sold me the second time to a surgeon for the price of 70 pieces-of-eight."

This surgeon not only treated Esquemeling for his illness, he taught him to read, write and eventually gave this obviously astute young man his freedom.

We take much for granted in our time, especially freedom. Most of us accept the state of being free without a second thought. We complain about lousy work situations, bad jobs, unfair bosses and low wages. "It's not fair!" is a mantra that echoes from the boardrooms to the factory floor. As bad as life can get in this day and time, it pales in comparison to the time of Phillip Orrill or John Esquemeling, when receiving twenty lashes for insubordination was common; when being worked literally to death was not only possible in some places, but probable.

*One for the master, one for the dame, and one for the little boy who lives down the lane.* It is difficult to imagine, given today's open society, that there was once a time when people were master, servant or slave. But this is part of our history. We cannot ignore it, nor should we fall into the trap of unfairly criticizing the past based upon today's acceptance of basic human rights. The injustices of earlier centuries are not our reality. Yet having the knowledge of what went before, understanding the unfair and difficult times that the uncountable Phillip Orrills experienced while they attempted to make a new life for themselves in a new land, merits remembering. With this, perhaps we can better grasp the importance of that most precious of all American commodities—*freedom.*

# Okra

*Some call it slime, (Not you, too!)*
*Some say it tastes like homemade glue.*
*Some like it fried and piping hot,*
*Some like it boiled in a great big pot.*
*Some like it pickled, (Spicy, too!)*
*Some like it cooked in a homemade stew,*
*Some like it chopped, and others, odd,*
*Like to eat the whole big pod!*
*Okra is delicious, okra is tops,*
*Okra slides right down without a stop.*
*And if you don't like to eat it (and we all do),*
*Then give it to the fisherman and God bless you!*

—From *Lowcountry Garden of Verse*

SOME YEARS AGO, MY SISTER was helping a group of pre-school children in Atlanta learn their ABCs. Choosing a letter from the alphabet, she would ask them to name a fruit or vegetable that began with that letter. With "A," of course, came the response "apple." With "B" came "banana." And so on until she came to the letter "O."

"What food begins with 'O'?" she asked, smiling.

The children didn't miss a beat. The entire class resounded in one happy chorus: "Okra and tomatoes!"

You can't get much more Southern than that.

Perhaps no other vegetable served from Lowcountry kitchens is as versatile or as enduring as okra. I, for one, cannot think of any more perfect meal than fried shrimp and white rice, the rice of course being topped with stewed okra and tomatoes. And pickled okra? It is the quintessential Southern hors d'oeuvre.

"Okra?" I can hear some Yankees amongst you gasp with disbelief. "But it's pure slime! Either that, or too tough." One Northerner I knew with a more poetic bent avowed that okra tasted like "buckshot in mucilage." There may be no other vegetable to meet with such partisan tastes as okra. Yet, as with most vegetables, liking okra "boils" down to a matter of taste. Cooked properly, okra is neither slimy nor tough and can be as delectable a green vegetable as fresh asparagus. Whatever one's taste, okra rates right up there with grits as an essential element of Southern cuisine.

Okra (*Hibiscus esculentus*) is actually a member of the cotton and hibiscus family and it blooms a lovely yellow blossom similar to that of the ornamental tropical hibiscus. Although it is grown throughout the world (particularly in South America, the Southern United States and India), the plant is a native of Africa, said to have originated in the region of Ethiopia and eastern Sudan. Okra's exact introduction to American shores is not known; it more than likely arrived in the eighteenth century with African slaves. Our word "gumbo" is taken from an African (Bantu) word for okra. Any Southerner knows that a gumbo, whether it is cooked with chicken, pork or shrimp, is not a true gumbo unless it contains okra as a main ingredient.

Diversity, one might say, is okra's middle name. Okra can be boiled, steamed, stewed, fried, canned, frozen, baked and pickled. It is served chopped or whole by the pod. Many Southerners believe that okra soup has medicinal powers equal to (or maybe surpassing) that of chicken soup. Stewed okra and tomatoes is a dish as culturally tied to the Old South as the cotton plantation.

For those who have a basic dislike of okra, no serving method is appealing. But for those who enjoy this wonderfully diverse summertime crop, recipes abound. One of the more advantageous qualities of okra is its low caloric value. Ten pods of steamed or boiled okra equal only twenty-eight calories, a dieter's delight (unless you top the servings with a rich hollandaise sauce). The calories also go up when it is sliced and deep-fried in a batter of flour or cracker crumbs. But who's counting calories when something tastes so good?

I have to admit that the varying uses of okra in some countries cause even an okra lover like myself to balk. New Guinea okra produces sorrel-like leaves that are edible. In Turkey and parts of the Orient, okra is dried before it is served. In France, a species of okra is used as a poultice for the chest. And in certain parts of the Mediterranean, ripe okra seeds are ground and used as a coffee substitute. "Another cup of okra dear? Cream, or sugar?"

Here in the South, our tastes run to more simple fare. Personally, I enjoy basic boiled okra which I flash-cook as I would asparagus. The secret of non-slimy okra is

in under-cooking. Choosing young, small pods since they are the most tender, I drop the pods into boiling, salted water and cook them until they just take on a deeper green hue, not more than a minute. I serve immediately and voila! Slimeless okra.

I've dreamed up one recipe for okra that would be a prime example of a true Lowcountry dish. And, oh, it would cause such lovely reactions—particularly with those who have nothing but bad things to say about either the South or okra. I'd call it "Okra Fantastique" and it would be a simple, easy-to-make casserole containing only two ingredients: okra and oysters.

"Slides right on down, don't it boy?"

# Where are the Rocks
# in Rocksville?

TRANQUIL, HISTORIC AND HAUNTINGLY BEAUTIFUL, the tucked away village of Rockville on Wadmalaw Island is as cloaked in sea island character as its ancient oaks are with Spanish moss. Nested between Bohicket Creek on one side and Adams Creek on the other, it is the quintessential Lowcountry setting, a drowsy place, where time is measured by the changing tide.

But rocks? The view from Rockville is of water, marshlands, Seabrook Island and the ocean beyond. In this part of the world, "rock" is what the boat does on the waves in the creek. So how did Rockville get its name?

Planters began settling on Wadmalaw Island soon after the founding of Charleston and by the mid-1700s, well-established island plantations were growing tobacco, indigo and, later, the highly prized sea-island cotton. One particularly desirable parcel was a 496-acre tract at the island's lower tip, originally granted to colonist Paul Hamilton in 1736. By the time it was purchased by Benjamin Jenkins in 1771, it had come to be known as The Rocks Plantation, the name given for a strange, rock-like substance that appeared at the southernmost point of the bluff on Bohicket Creek.

This substance was phosphate rock, an ore rich in calcium and other minerals. Its story begins during a prehistoric time when the South Carolina Lowcountry resembled a scene from *Jurassic Park*. Phosphate was formed from the fossilized remains of mastodons, giant sharks and other prehistoric creatures of that era. "It is hard like any other rock, overlying the river beds to an average thickness of eight inches to a foot," wrote a writer on sea island phosphate in 1877. "It is of a dark greenish-brown, and is full of fossil bones of mammoths, 'monsters of the slime' of other ages, and oyster shells of enormous size."

Phosphate beds were found throughout the Lowcountry's tidal basins and, while most were underground (or underwater) and thus unseen, presumably the tidal action against the side of Rockville's bluff made this particular vein visible. High in lime content, phosphate is a natural and potent fertilizer, a type of mineral manure. During the economic decline following the Civil War, phosphate mining and preparation became the Lowcountry's major industry, with fifteen phosphate works in Charleston alone. In the early days of settlement, however, phosphate's use had yet to be discovered. The "rocks" in Rockville's bluff were an oddity, something to give a plantation a name.

The early planters recognized the bluff's exceptional waterfront location. Facing south over the expanse of the lower North Edisto River, the bluff received the cooling breezes that blew in from the ocean. The Rocks Plantation was an ideal spot to spend the hot, humid summers.

Thus, in the late 1700s, area planters such as Micah Jenkins, Benjamin's nephew, began to build summer homes along the bluff. Others followed, the names reading like a *Who's Who* of sea island plantation society. By the early 1800s, a line of summer homes fronted the creek, owned by the Townsend, Adams, LaRoche, Bailey, Sosnowski, Chisholm and Seabrook families. The village of Rockville was born, supported by a store and a church, Grace Chapel, which came to be colloquially known as "the church on the Rock."

No rocks (or rock-like substances) are in Rockville any longer. The first to mine Rockville's phosphate were the Union soldiers who occupied the area during the Civil War. The remaining deposits went in the 1880s to the numerous Lowcountry phosphate works, such as the one on the upper Ashley River at the terminus of, you guessed it, Ashley Phosphate Road.

What does remain is a rock-solid determination by the residents to keep Rockville and Wadmalaw Island from succumbing to the over-development that has altered the character of other sea island locations. One exception occurs when the village is again "occupied" on the last weekend in August, as thousands of people come to watch the sailboats race during the popular Rockville Regatta. One long-time Rockville resident tolerantly described this annual influx. "It's kind of like the tide. They come in, have a good time, and then, thank the Lord, they go out again." For the rest of the year the village retains its enviable state of cherished anonymity. Rockville is a precious and peaceful gem in the Carolina sea island setting.

# Frankly, My Dear, it Was D*mn Risky Business

THE NIGHT WAS BITTERLY COLD and a lashing east wind had whipped Charleston harbor into a cauldron of angry waves. The sky was black and moonless; dark, low clouds soon pelted torrents of icy rain.

Huddled in a floating clutch in the waters offshore Morris Island, the ships of the Federal blockading fleet rolled and listed as they rode the wind-driven waves of the nor'easter. No sane captain would dare venture out on such a night.

But on the Charleston waterfront one vessel was building up steam to sail—a streamlined side-wheel steamer built for speed and hauling cargo. This was a Confederate blockade runner, laden with cotton, and the captain knew that this night with all its perils was ideal for slipping through the blockade.

Once at sea, if they made it without wrecking in the storm, they'd sail for Nassau. There the cotton would be sold at a premium and the ship would take on an even more precious cargo—guns and ammunition for the Confederate army. The ship would then sail back to Charleston and, with luck and sheer boldness, make the dangerous run through the floating gauntlet of Union gunships called the Federal blockade.

It was risky business, blockade running. Yet it was absolutely vital to the Confederacy. With no industrial base, almost all of the South's supplies had to be procured from abroad. As a major Atlantic port, Charleston soon became a leading blockade running port.

This, perhaps, is why in *Gone With the Wind*, Margaret Mitchell created the infamous Rhett Butler as a blockade-running captain from Charleston. Some 250 ships ran or attempted to run the blockade from Charleston during the war. Like the fictional Butler, the captains of these vessels were shameless risk takers.

Stealing out in darkness and bad weather, they ran their swift steamers past the Federal gunships and out to sea. A clean shot from a Union gunship could mean disaster. Even in good weather, maneuvering a ship through the shoals at the harbor entrance was tricky. Not all ships made it.

But for those willing to take the gamble, the money to be made was immense. For others, they lost their money as quickly as they could gamble it away.

"I never expect to see such flush times again in my life," noted one captain whose tales were later related in the 1885 *Charleston City Directory*. He described high times in Nassau, which, like Bermuda, was a central port for blockade runners. "Money was almost as plenty as dirt. . . . Men wagered, gambled, drank and seemed crazy to get rid of their money. I once saw two captains put five hundred dollars each on the length of a certain porch. Again I saw a wager of eight hundred dollars a side as to how many would be at a dinner table at a certain hotel."

Yet blockade running had a value far beyond monetary worth. Rightly called the lifeline of the Confederacy, it was the only way the Confederate army could clothe, feed and arm its soldiers. In the last six months of 1864, the goods brought in through Charleston and Wilmington alone included 500,000 pairs of shoes, 300,000 blankets, 3.5 million pounds of meat, 1.5 million pounds of lead, 50,000 rifles and 43 cannons.

Perhaps Charleston's most valuable asset was the import-export firm Fraser, Trenholm & Company, whose senior partner was George Alfred Trenholm, one of the richest men in the United States. Trenholm's financial interests were vast, including involvements in banking, railroads, hotels and shipping. As a leading international broker for cotton, the firm had offices in England and enjoyed almost unlimited credit abroad. Among his vast Charleston landholdings was his home on Rutledge Avenue, the elegant Regency villa now known as Ashley Hall School.

With war, Trenholm turned his substantial financial base toward the support of the Confederacy. The company became the exclusive overseas banker for the Confederate government, financing the purchase and importation of armaments and other essential goods. This, of course, involved blockade running, which Trenholm not only backed financially, but for which his firm also built and outfitted the ships.

Was Trenholm, as some historians have suggested, the "real" Rhett Butler? The answer is yes, and no.

Like the dashing Captain Butler, Trenholm was handsome, wealthy and involved with blockade running. Yet Trenholm was in his mid-fifties when war erupted. Moreover, he was a family man. His wife, Anna Helen Holmes, was from one of Charleston's leading families and the couple had thirteen children. Where the fictional Butler was such a blackguard that the mere mention of his name would send Aunt Pitty Pat into the vapors, the real Alfred Trenholm was a man as solidly respected as St. Michael's steeple.

This, and his unfailing support of the Confederacy, earned Trenholm the position of Secretary of the Confederate Treasury in 1864. It has been rightfully stated that Trenholm had perhaps more influence in governmental affairs than most generals and politicians.

Like other members of the Confederate cabinet, Trenholm was taken prisoner by Federal troops following the war. He was held near Savannah until late 1865, when he was pardoned by President Johnson. Returning to Charleston, he characteristically turned his vast energies into rebuilding the city.

While the fictional Rhett Butler will forever remain a dashing but beloved scoundrel in the pages of a novel and on the silver screen, the real George Trenholm was a man of undisputed integrity and community spirit. Perhaps the only similarity between the two men is that they were both in the business of running ships through the blockade, an occupation rife with danger but promising a fortune to those willing to take the risk. Trenholm died at his home, Ashley Hall, in 1876. Despite his immense wealth, he was buried under a simple headstone at Magnolia Gardens.

As for the fancy hat that Rhett brought Scarlett from Paris after one of his runs through the blockade? Fiddle-dee-dee. Such frills were spurned by the proud Confederate women who "scorned to wear a dress of silk or a bit of Northern lace." Championed in a wartime song called "The Homespun Dress," written by Carrie Belle Sinclair of Savannah, the lyrics reflect the Southern woman's enthusiastic support of the blockade runner. "The homespun dress is plain, I know—my hat's palmetto, too; But then it shows what Southern girls for Southern rights will do. Now Northern goods are out of date, and since old Abe's blockade, we Southern girls can be content with goods that's Southern made!"

# A River Runs Through Us

C AROLINA DOTH SO ABOUT IN rivers," wrote colonist Samuel Wilson in 1682, "that with fifty miles of the Sea, you can hardly place yourself seven miles from a navigable River."

One thing we have plenty of here in the Lowcountry besides gnats, mosquitoes, extremely hospitable people and pluff mud is water. All exist on the edge of that vast sea which, as a young child, my friend Paul Keegan called "The Great Atlantic Notion."

Paul has since gone to surf that Great Wave in the Sky but, in his life, he truly loved the ocean. This was a good thing, for him and for all of us, because if we didn't like water, we wouldn't be very happy living in a place where there is such an abundance of it.

I am told that 500,000 more people are expected to settle on the South Carolina coast in the next twenty-five years. I have a theory about why people gravitate (that's an extremely good word in this context) toward the sea. It has to do with the moon, the tides and our bodies. I will try to explain.

When I was a child living on lower King Street just a block from the Battery, I could tell whether the tide was high or low without even looking at the harbor. Was this uncanny ability the result of some sort of eerie, extrasensory perception I held and which conjoined me with the vast, empyreal sea? The possibility was considered, particularly by out-of-town company who found my mysterious ability to predict tides as intriguing as a parlor game.

In truth, to see if the tide was high or low all I had to do was go to the bathroom and meditate. I said no mantras. This required no supernatural introspection. All I had to do was check the level of the water in the toilet bowl.

That was back in that era of pre-sewage treatment plants, when our drainpipes were directly connected to the harbor and, consequently, the harbor was directly connected to raw sewage. One didn't swim in the harbor then. One did not even place a toe in the harbor's filthy water. Probably the greatest modern achievement of our time is the construction of the Plum Island sewage treatment facility. Today, the harbor is clean.

But consider this: The rise and fall of the tides are influenced by the moon. As the moon orbits the earth, the moon's gravitational forces go to work with the earth's centrifugal forces, creating tides. As the earth rotates, the tides fluctuate from high to low. What do you suppose this gravitational pull does on human beings whose bodies are, after all, 80 percent water?

Ask anyone who works in an emergency room or in law enforcement and they will tell you that their business peaks during a full moon. The gravitational pull appears to cause a certain lunacy, which is how that word came about in the first place, *luna* being the Latin word for moon.

Frankly, the possibility of sharing the finite boundaries of our already crowded coastline with a half-million more people is, to my way of thinking, lunacy. Yet people are pulled, either by gravitational force or by the allure of the sea, to live along the water's edge. It has been so since the very beginnings of colonial settlement.

Of course, back then, one of the main reasons people settled along a watercourse was for transportation. There were no roads to speak of and those that did exist were in pretty poor shape. With this plentitude of rivers and creeks, all one needed was a canoe to get from one place to another. In the eighteenth century, the French Huguenot Church even planned Sunday services around the tides. So many in the congregation resided on Cooper River plantations and their main mode of transportation to Charleston was by boat. One contemporary writer noted that they arrived "by families, in their canoes, at the public landing at the foot of Queen Street, preserving a religious silence, which was alone interrupted by the noise of their oars."

Can you imagine how appalled these worshipers would have been to have their "religious silence" shattered by the buzz of a flock of frenetic jet skis joyriding by?

Five hundred thousand more people in the next twenty-five years? That's a lot of sewage, folks. Not to mention additional boats, jet skis and docks all vying for their place by the riverside.

Stemming this particular (ahem) "tide" is not going to be easy, or enjoyable. Some years ago the state of Oregon, facing a similar dilemma, ran a superb television ad. It showed a man standing under an umbrella in a pouring rain (of which Oregon has plenty), touting the many reasons why someone should come and visit their beautiful state. You watch, thinking, "with all that rain?" Then as the commercial ends, the camera pulls back to show that the narrator is standing in full sunshine under a rainmaking machine. Then comes the tagline, and I paraphrase: "Oregon. A Great Place to Visit. Just Don't Come Live Here."

Maybe we should consider doing something along the same lines. "*You* are made of water," the ad could read. "Do *you* want *your* body to rise and fall with the tide? *This could happen* if you live on the coast. *Don't* come live here. Living near water can *make you crazy!*"

If you don't think the idea has merit, try living with 500,000 additional people. That is madness. It will make us crazy, all right. Crazy enough to howl at a full-tide moon.

# Ripley's Light

L IKE WORDSWORTH'S "LIGHT THAT NEVER was on sea or land," the once prominent
harbor navigational station known as Ripley's Light is now remembered only
in name as Ripley's Light Marina on the Ashley River. Yet until 1932, Ripley's
Light, and before that, Fort Ripley, was the closest harbor feature seen from the
Battery at White Point Gardens.

The story of Ripley's Light began during The War—that war—the one between
North and South. In 1862, as Charleston strengthened her harbor defenses, the
Confederates decided to build a small fortification to protect the inner approach
to the Ashley River. Built on a shallow bar in the Ashley River called the Middle
Ground, the square, bulky, timber-built harbor fortification was strategically located
midway between Castle Pinckney and Fort Johnson and rose thirty feet above the
water. Although it carried an armament of seven cannons, it was described by one
contemporary as being "hardly shotproof." In fact, the fort never saw direct action
during the war. More memorable were the people involved with its making and its
later role as a lighthouse station.

The man for whom the fort was named was the resolute General Roswell Sabine
Ripley (1823-1887). Ripley was the quintessential military man—an outspoken,
spit-and-polish graduate of the West Point class of 1843 who had served with
distinction during the Mexican and Seminole wars. He eventually became chief
of military operations for the Charleston District of the Confederate Army.

During the first bombardment of Fort Sumter, Ripley was at Fort Moultrie
as chief of artillery. He did his job well. The eighteen hundred rounds fired at
Fort Sumter heavily damaged the fort's upper story before the Union garrison

capitulated. Young Private William Gourdin Young remembered Ripley for another reason. In the midst of the bombardment, Young had volunteered to accompany Senator Louis Wigfall in a small boat to carry a flag of truce to Fort Sumter. The boat, a flimsy affair, was taking on water as it approached Sumter. It was also receiving shots—not from the Yankees at Sumter but from the Confederates at Fort Moultrie.

When "a third shot splashed water over us," wrote Young in his memoirs, they realized that they were the target of not-so-friendly fire from the guns at Fort Moultrie. "General Ripley informed me afterwards that he had ordered the boat sunk . . . he said, 'Some d—— politician was meddling with what he had no business and he intended to sink him.'"

Controversial and controlling, Ripley was an able military leader who was both admired and detested for his unrelenting ways. When General Alfred Roman wrote to a comrade complaining of an order given by Ripley, he added this not so subtle touch of sarcasm, "His activity and untiring zeal are familiar to all in this military district."

An example of Ripley's fastidious disposition is remembered in the local legend of how Fort Ripley was named. As told by the late historian Jack Leland, "Ripley went to inspect the then-unfinished fortification, attired in his accustomed military finery, complete with polished boots, scabbard and sword and gold epaulettes. A sudden wave motion caused the boat to veer away from the fort and Ripley went 'ker-plunk' into the briny."

As Ripley was pulled out of the water, "he came up spouting water and furious," wrote Leland. "As he was hauled out onto the sandbag platform, he surveyed the scene and said: 'I don't care if you name it fort son-of-a-bitch.' And so, proving that they at least had a sense of humor, the Confederates named it Fort Ripley."

Fort Ripley was first under the command of Captain Henry S. Farley, First South Carolina Artillery, Company H. Farley is distinguished in his own right for his role in the first bombardment of Fort Sumter. Although the firing of the first shot has often been attributed to the elderly Virginian and staunch secessionist, Edmund Ruffin, most historians agree that the opening shot was a signal shot fired from the beach battery near Fort Johnson. This shot was likely fired by then-Lieutenant Farley under orders of Captain George S. James. The second shot was fired by Lieutenant Wilmot H. Gibbes. The honor of the third shot was given to Ruffin.

Following the war, Fort Ripley began to erode and was eventually declared a navigational hazard. In the 1870s, however, the federal government appropriated $20,000 for the construction of a lighthouse on the reef. Erected in 1878, this two-story, hexagonal-shaped building was built on steel pilings with a circular lighthouse atop the roof. The light carried 150 candlepower and a bell rang during foggy weather. One of several inshore lighthouses along the South Carolina coast, it was eventually deemed obsolete and discontinued in 1932.

The story, however, doesn't end here. When dismantling the structure, workers found a wooden slab between the walls dated 1878 on which the workers who had built the original structure had written: "This is to certify that Chas. Anderson and Simons Bruns did (lustily) swear against the reduction in working hours to the supt. Maj. Gowers." On the reverse side was carved: "In God we trust—as we can't trust the U.S. Government."

# A Day on a Shrimp Boat

THE ALARM RANG AT 3:30 a.m. In less than half an hour, sleepy-eyed, I was scrambling aboard the *Easy Lady* docked at Shem Creek. I was the late arrival; the others had assembled earlier to load ice and fuel. I'd hardly stowed my things before Captain Dean Smith started the engine, eager to be off so that by 5:00 a.m., the legal time for dropping the nets, we'd be off Morris Island. We headed out Shem Creek and into the night under a full moon, on water as smooth as silk, part of a line of trawlers similarly setting out for the day of shrimping.

First off, let me say that Captain Smith's crew that Saturday was not what you call the norm. There were six of us aboard, three women included, and Smith can easily shrimp with a crew of one. For that matter, since *Easy Lady* is a compact 41-foot trawler with an adapted A-frame trawling rig at the stern, Smith has things engineered so, if need be, he can shrimp alone.

But why do so when you have boon companions who will eagerly agree to a day of striking (a shrimp boat's crew member is called a striker) and the chance to spend a glorious summer day on a boat offshore? Besides, what sane captain would refuse the chance to have friends aboard, particularly three women in bathing suits?

So off we went—Allison and Herb, Marlene and Duane, Doty and myself— with Dean at the helm, cigar in his mouth and Pepsi in hand. We were missing one important crewmember, Captain Smith's significant other, Florence (a.k.a. "Pookie"). She was in Virginia delivering last week's catch. Talking over the roar of the diesel, we breakfasted on boiled peanuts and a cold brew. Not a bad way to start the day.

We headed out the narrow channel between Mount Pleasant and Crab Bank, then, sliding by Fort Sumter and Sullivan's Island, we slipped through the opening at the end of the south jetty called Dynamite Hole and proceeded southwest. Offshore was the shrimping fleet, a tight line of over fifty bobbing lights, so many it looked as if we were approaching a land mass which had magically emerged from the sea during the night. This was early in the shrimp season and the fleet was large. As the season progresses the number of boats will diminish, a result of the predictable breakdowns and engine problems that perpetually plague this already tenuous industry.

At just after five, Smith slowed *Easy Lady*'s engine and made ready to drop the nets. Different from the more familiar trawlers with outriggers that drag nets from each side of the boat, *Easy Lady*'s nets are dropped from the stern. This is done through an ingenuous, Rube Goldberg-type invention of lines, steel cables, pulleys and gears. With engine controls located on the starboard side near the stern, Captain Smith deftly used the power of the engine to help kick the nets in the water and they slowly and steadily streamed behind the boat. He then set the engine at trawling speed, about 2 ½ knots. The first trawl had begun. It would be about three hours before the nets were hauled in.

I have had very few experiences to equal the sunrise that Saturday as we made that lazy first run off Morris Island. We were on a calm, undulating sea. As the sky lightened, I could read the familiar names of the boats around us as they rocked back and forth with the swells, their outriggers out. Most were Shem Creek boats like the *Carol El*, *Sea Tractor*, *Playboy* and *Miss Alva*. Others were home-ported elsewhere like Glenn Milliken's handsome, 75-foot *Captain Jeffrey* from Fernandina Beach.

Amidst this picturesque setting, to the east, the rising sun was painting the horizon in splashes and streaks of vivid orange, salmon and pink. Simultaneously, to the west, the full moon was setting. In a spectacular moment of celestial choreography, we watched the moon become an enormous orb of burnished copper and descend behind the regal black-and-white outline of the Morris Island lighthouse. It was one of the most magnificent sights I have ever beheld.

"Time keeps on slippin', slippin', slippin' into the future." That Steve Miller Band song kept playing in my head as I experienced the slow business of shrimp trawling for the first time. Not much happens during the three-hour period the nets are in the water. Every fifteen minutes to a half hour, Smith would check the "try" net, a small net lowered from a boom on the starboard side that helps him gauge how many shrimp are in the vicinity and whether he's shrimping in the right place. The try net catches were good. Smith returned to the cabin and helm, steering the boat, watching the depth finder and talking to other captains on the radio.

As for the rest of us? It was time for a nap. I took the advice of the others and quickly discovered that there is nothing, not anything, better than a snooze atop the large console that surrounds *Easy Lady*'s Detroit Diesel. The rhythm of the engine mixed with the slow, steady rocking of the boat was as soothing as a baby's cradle.

Our slumbers came abruptly to an end when the net was brought up. It was then that I discovered that some on our motley crew were seasoned strikers and knew exactly what to do and when to do it. This is not merely helpful, it is important. Hauling in the net is tricky business and rife with danger. The "doors," large, heavy wooden platforms that hold the nets open as they drag along the bottom, are unwieldy when out of water. Until properly secured, they swing dangerously even on a gentle sea. I can imagine what they do in rough water.

Even with the help of motorized pulleys and Captain Smith's skilled ability in using *Easy Lady*'s powerful engine to skip the doors and nets upwards, this is hard work. We're talking brute strength. It must be done adroitly or else nets can foul. Moreover, you're not only hauling in the mass of block-long nets, at this time of year they are filled with the additional weight of hundreds of jelly balls—large, round, harmless jellyfish blobs which come to Carolina waters in the early summer by the millions. Also, there is the additional bulk of the TEDs (Turtle Exclusion Devices) and the large, triangular Fish Finders, attached by law to every commercial shrimp net to protect sea life.

Finally, it was done. The doors were secured. The nets were out and hanging over the platform on the stern. As Captain Smith untied the bottom of the net, a rush of sea life scattered out into a writhing heap. Then, with the nets returned to the water for the second drag, my first job as a striker/sorter began. This is no work for the squeamish.

Large crabs, small crabs, crabs with spines and crabs with spots scurried toward the side and freedom, snapping claws wildly in the air. Amidst a tangle of seaweed and starfish were hundreds of squirming squid and a sea hag's assortment of fish. There were long, sleek, eel-like fish, fish with spines and fish with teeth. Stingrays flapped, swinging tails that carry barbs. There were nasty little hard-shelled, shrimp-like creatures that can bite with a vengeance. The occasional shark. The goal is to clear as much of this "trash" as possible, getting this roiling mess of sea life back into the water while, at the same time, culling out the shrimp. Gloves are recommended.

It is at this point that you discover that yes, there *is* such a thing as a free lunch if you are a gull, a pelican or a porpoise. We were surrounded by sea birds, diving and swooping with screams of delight as the trash entered the water. And almost close enough to touch were the porpoises, just as eager for the easy meal as their avian compatriots above.

*Easy Lady*'s catch that Saturday was moderate. What we didn't bring home in poundage was offset by the incredible size of the shrimp. I personally culled one shrimp that was a good eight inches long. After nine hours aboard a professional shrimp boat, I came home, tired, sunburned and happy, carrying a hefty bag of shrimp, enough squid for a platter of fried calamari, a sizable filleted shark and a very nice flounder.

I also returned with the knowledge that this is a profession that takes a strong back and a sixth sense of the sea. As Captain Glenn Milliken, who has been shrimping for forty-five years, told me, "Any time you don't think that place can't drowned you, remember this: you CAN go to the bottom." Shrimping as a profession is not for me, but I'm proud and privileged to know those who make it theirs.

# Mark Catesby:
# Artist, Naturalist, and Explorer

A S I ARRIVED AT THE beginning of the summer," wrote English naturalist Mark Catesby (1679-1749) following his first trip to Carolina in 1719, "I unexpectedly found this country possessed not only with all the animals and vegetables of Virginia, but abounding with even a greater variety. The inhabited parts of Carolina extend west from the sea about sixty miles, and almost the whole length of the coast, being a level, low country. In these parts I continued the first year searching after, collecting and describing the animals and plants."

Well-deserved credit has been given to John James Audubon for his discoveries and artistry of North American flora and fauna. Yet it was Mark Catesby, predating Audubon by a full century, who would be the first to catalog, paint and, in some instances, name the wildlife of the southeastern American region. Catesby's first visit to America was in 1712 to Virginia. He would return in 1719, this time to explore the Carolinas, Florida and the Bahama Islands.

It was a wild, supreme beauty the forty-year-old Catesby encountered. The interior lands were *terra incognito,* known only to fur traders and the various Native American tribes who lived in the remote interiors. With Indian guides, Catesby explored these hinterlands from the mountains to the sea, writing of "hunting buffalo, bears, panthers, and other wild beasts. In these excursions I employed an Indian to carry my box, in which, besides paper and materials for painting, I put dried specimens of plants, seeds, etc.—as I gathered them. To the hospitality and assistance of these friendly Indians, I am much indebted, for I not only subsisted on what they shot, but their first care was to erect a bark hut, at the approach of rain to keep me and my cargo from wet."

Catesby described the wild things he encountered, both animal and vegetable, in exquisite detail. "With plants," he wrote, "I had principally a regard to forest trees and shrubs, showing their several mechanical and other uses, as in building, joinery, agriculture, food and medicine. I have likewise taken notice of those plants that will bear our English climate." He then carefully preserved seeds and seedlings for shipment back to England.

"As there is a greater variety of the feathered kind than of any other animal," he noted, "and as they excel in the beauty of their colors, and have a nearer relation to the plants of which they feed on and frequent, I was induced . . . to complete an account of them." Indeed, his listing of birds was remarkably thorough and he believed that " very few birds escaped my knowledge, except some water fowl and some of those which frequent the sea."

In some instances, Catesby was the first to give birds the names we know them by today. "Very few of the birds having names assigned them . . . except some which had Indian names, I have called them after European birds of the same genus, with an additional epithet to distinguish them." The mockingbird, for instance, was Catesby's "Mock Bird.""The Indians," he wrote in his description, "by way of eminence of admiration, call it 'Cencontlatolly,' or four hundred tongues."

Catesby would also illustrate the flora and fauna of Carolina. "As I was not bred a painter," he wrote, "I hope some faults in perspective, and other niceties, may be more readily excused."Catesby need not have apologized. He was a natural artist and his technique, to that time, was masterful. Also, rather than painting the single bird or plant, he melded his subjects into a work that illustrated their relationship with the overall habitat.

"In designing the plants," he wrote, "I always did them while fresh and just gathered; and the animals, particularly the bird, I painted while alive (except a very few) and gave them their gestures peculiar to every kind of birds, and where it could be admitted, I adapted the birds to those plants on which they fed, or have any relation to. Fish which do not retain their colors when out of their element, I painted at different times, having a succession of them procured while the former lost their colors."

In 1731, Catesby's notes and paintings were produced in a folio publication entitled, *The Natural History of Carolina, Florida and the Bahama Islands, Containing the Figures of Birds, Beasts, Fishes, Serpents, Insects and Plants, etc.* This work also included one of the first and most thorough descriptions of the southeastern Native American tribes, their physical attributes, customs and manner of living.

There were many narratives of Carolina during the early 1700s, but few were equal to Catesby's in depth of description. His was a remarkable talent. As an artist, he left for posterity an impressive portfolio of illustrations of the region's flora and fauna. Perhaps his foremost talent was that of an astute, impartial observer. An explorer, artist and accomplished writer, Catesby's legacy to succeeding generations was perhaps the greatest gift of all—a look into the past.

# A March Through the
# Sea Islands in 1862

In June 1862, Confederate forces from James Island to the Beaufort area were ordered to halt an expected invasion of Federal forces on the railroad line at Pocotaligo. One of the Confederate soldiers on James Island was Samuel Cosmo Lowry, nicknamed "Catawba" for his Upcountry home in York County, South Carolina. Lowry was barely seventeen when he enlisted with the Carolina Rifles, a unit commanded by his uncle, Captain William Wilson. Lowry kept a diary of his wartime experiences, and the action he saw on James Island is vividly recounted, portraying the commitment, confusion and, at times, pure drudgery of the ordinary Confederate foot soldier.

The following from Lowry's diary recounts a difficult nighttime march to Jehossee Island, near Edisto. When necessary, I have made annotations to help explain some of the people mentioned. The Holcombe Legion, for instance, was a unit under the command of Major (later Brigadier-General) Stephen Elliott of Beaufort, named in honor of Lucy Petway Holcombe Pickens. She was the wife of Governor Francis Pickens and admired for her great beauty. I've left intact most of Lowry's misspellings and grammatical errors but I have split his narrative into paragraphs for clarity. One can only imagine that this diary was written in great haste and under very difficult circumstances.

*Gen. [Nathaniel] Evans arrived and ordered us to leave the Island, and our whole force, excepting the cavalry, left, consisting of Dunovants [Colonel R.G.M. Dunovant] regulars, 16th regiment, and ours, the 17th . . . .*

*An attack was planned on the enemy at Edisto Island to be led by Col Stevens [later Brigadier-General C.H. Stevens, of Charleston] of the Holcombe Legion, an able and excellent officer. First*

*we went to Adams Run, the headquarters of Gen. Evans, about 12 miles distance from our camp. Here we met up with one or two other Regiments bound on the same expedition. In truth, our force was very small, being only the Holcombe Legion, 17th regiment . . . and some other separate commands of artillery and cavalry. A small force to undertake to drive 10,000 Yankees off an Island so well fortified and defended.*

*When we arrived at Adams Run we halted and spent the night out in the streets. The next day, by daylight we were on the march for Edisto. We walked all day under a scorching sun, suffering from thirst and fatigue. We at length arrived at Pinebury the place of crossing over to Jehossee Island, at about sunset, having only one large flat to cross the whole body, we were a long time getting over. Our Regiment did not get over until about nine at night, when we took a small embankment for a path, thrown up just between the rice dams and the river, only a yard wide, with very tall grass growing on each side of it. It needed only one misstep to either side to precipitate us into the river on one side of the rice dam or the other, but luckily for us the moon was shining brightly. We kept up this narrow path for about 1 mile, following the course of the river until at length we reached a road leading to Ex Gov. [William] Aiken's plantation, and following it, soon reached his wealthy farm. It ought to be called a village as I never saw so great a number of negro houses together to be owned by one man and on the whole so well fixed. We stopped here to rest, it was then about 12 o'clock at night.*

*When we had hardly gotten seated on the ground a courier came dashing through our ranks at headlong speed saying that the enemy was endeavoring to cut us off with their gunboats by sailing up the river, and were prepared to receive us on the Island...and as only half of our forces were yet over on Jehossee, orders were given for us to retreat. We immediately marched back, leaving a picket behind, and taking the same route by the narrow path proceeded very slow and did not reach the ferry until about two o'clock and were then compelled to stand in this narrow path for three hours and half before we could cross. The tide having fallen, we were compelled to wade thigh deep in mud and water before we could reach the flat, but we got over safe at last just as the gray tint of morn began to appear on the eastern Horizon.*

*Having walked the whole night and the day previous we were pretty well wearied and took a good rest at Pinebury, and about ten a.m. started for camp which we reached the following day. Our march being all for nothing as it turned out to be. This was the last march of any consequence that we took on the coast*

*Our next experience now came to possess more the appearance of stern reality, and instead of false alarms we came to sturdy blows, and close contest with a powerful enemy. We received the orders to repair to the Old Dominion, the land of fights, and were soon on the way.*

After Secessionville, Lowry's regiment was sent to the battlefields of Virginia. The final entry in his diary, "go back to the ditches tonight," was dated July 30, 1864, just to prior to the Battle of the Crater, Petersburg. Sadly, nineteen-year-old Samuel "Catawba" Lowry was killed during this battle.

# Appeasing Jurakan

THE ANCIENT INDIANS OF THE Caribbean called the great god of storm and fury Uracan, the evil spirit. He was Jurakan to the Mayans of Mexico, so fearsome he could only be appeased by human sacrifice. The Hondurans called him Kukulkan— supreme god of gods—and they blew trumpets into the air when the winds rose in an attempt to placate his fury. Finally, it was the early Spanish conquistadors who, as they prowled the Caribbean in their quest for gold and silver, combined these names into one—*huracan.*

Defined in meteorological terms, a hurricane is an Atlantic Ocean tropical cyclone with winds of over 74 miles per hour. A hurricane is perhaps better described as a disruptive, destructive blow of wind and rain that roars with the irrational fury of a spoiled child. Roofs fly; walls fall. Low-lying areas drown in the mighty onslaught of the storm surge. "MINE!" the winds scream as they pull trees up by their roots. "It's MINE! All MINE!"

What makes a hurricane a hurricane, and not simply a severe low-pressure system, is when there is an area of high pressure directly above the storm called an *anticyclone*. It is this pull of high pressure above the low pressure that, much like a vacuum cleaner, literally sucks the warm moisture up, creating a partial vacuum in the eye. Because of the earth's rotation, the winds spin around this center in a counterclockwise rotation. The greater the difference between the air pressure outside the hurricane and the partial vacuum inside the storm determines the strength of these winds.

Because of the many other variables of weather—upper-level steering currents, water temperature, land masses and other weather systems in the atmosphere—it

is extremely difficult, if not downright impossible, to accurately determine the path of a hurricane.

The most sophisticated computer modules can only provide educated guesses as to where and when a hurricane will make landfall. These atmospheric vagaries also make it difficult to determine the strength a hurricane will have when it strikes. A hurricane is ever evolving, changing on a moment-by-moment basis like a feather floating in air. Its movements and strength are continually affected by conditions inside and outside the storm.

Where Jurakan has his wrathful eyes set on landing is as unknowable as the number of tropical storms that will be spawned during a hurricane season. Yet when the winds blow, the results can be catastrophic.

On September 15, 1752, one of the most powerful storms ever to hit Charleston roared in. This monster storm began about four in the morning, when, according to the *South Carolina Gazette*,

*The FLOOD came in like a bore, filling the harbor in a few minutes. Before 11 o'clock, all the vessels in the harbor were on shore . . . all the wharves and bridges were ruined, and every house, store, &c, upon them beaten down, and carried way . . . The town was likewise overflowed, the tide or sea having rose upwards of Ten feet above the high-water mark at spring-tides... The inhabitants, finding themselves in the midst of a tempestuous sea, the wind still continuing, the tide (according to its common course) being expected to flow 'till after on o'clock, and many of the people already being up to their necks in water in their houses; began now to think of nothing but certain death: they were soon delivered from their apprehensions for, about 10 minutes after 11 o'clock, the wind veered to the E.S.E. and S.W. very quick . . . the waters fell about 5 feet in the space of 10 minutes, without which unexpected and sudden fall, every house and inhabitant in them, must, in all probability, have perished.*

While statistics for hurricane strikes are available, hurricanes have a deplorable record when it comes to abiding by the rules of probability. They go where they want to go and do what they want to do when they get there. No amount of prognosticating, calculating or cogitating can alter a storm's course or the frequency of hits. Two of the most powerful hurricanes to ever strike Savannah, for instance, both arrived in August, twelve years apart, *on exactly the same date.* On August 27, 1885, and on August 27, 1893, the city was pounded by storms the size and strength of 1989's Hurricane Hugo. Taking this eerie statistic further, a Category 2 storm also hit the Georgia coast on August 28, 1881.

"Horrors of the Cyclone!" reported the *Savannah Morning News* following the storm of August 27, 1885. "The Fiercest Gale Ever Known. All Favorite Resorts Visited With Wreck and Ruin. The Streets Littered with Debris and Blocked with Prostrate Trunks. Tybee Cut Off. Death and Destruction."

This was a "coast hugger" storm, one that began in the Atlantic before it scurried up the coast from Florida. By the time it arrived in Georgia, it was blowing a low Category 3. It tore into Savannah with a vengeance.

The city's squares were "shorn of their magnificent beauty" with hundreds of downed trees. Church spires toppled. The wharves and waterfront were left in shambles, littered with debris. Homes not protected by Savannah's bluff slipped into the river with the storm surge. When the waters receded, ships were left high and dry on Hutchinson Island, which had been completely inundated during the storm. Between 600 and 800 people died.

In recent years, the primary roaring one hears most about hurricanes comes from an often over-zealous television media. On both the national and local scene, top billing has been given to even minor tropical storms—a sky-is-falling mentality that has bred both unnecessary anxiety as well as complacency. When one hears, "run for the hills!" every time a tropical system forms in the Caribbean, it becomes difficult to know when the real wolf is huffing and puffing at the door. The awful traffic snarls of 1999's Hurricane Floyd, despite the very real danger that storm presented, also dampened sensibilities.

Like any other decision made on good judgment, common sense is the best guide when listening to the various prognostications of doom and destruction. A tropical storm with peak winds of forty miles per hour is not a major hurricane and does not require battening up the hatches and heading for the mountains. A hurricane of Category 1 or above, however, is a serious matter and bears close attention.

While designating a storm's strength by category helps define its potential power, each storm is different and carries its own idiosyncrasies. It is not necessary to experience a Category 2 or 3 hurricane to see catastrophic effects. A weak Category 1 can inflict serious damage if it hits at a high tide.

Some storms carry wind; others rain. Some blow through rapidly; others dawdle. Hurricane Floyd hung off the North Carolina coastline for days, scouring beaches and dumping torrents of rain. The resulting flooding caused damage hundreds of miles inland with a price tag in the multi-millions of dollars.

Early accounts used far more descriptive terms in describing a storm's power. Verbiage such as, "driven from their homes through the pelting of the pitiless gale," and, "the homes came down like cardhouses," tell the tale with graphic realism. For those who weathered such storms in days gone by, evacuation was not an option. They were caught unawares and with nowhere to go.

Obviously those who live on the beaches and rivers, in lowlands and in areas prone to flooding need to keep a sharp eye on even small tropical systems. Their hammering downpours can create flash floods quicker than you can say, "the paddle is in the rowboat." Those who live in house trailers and mobile homes, no matter where they are located, should automatically think twice before staying through any storm system, severe thunderstorms included.

Above all, if the authorities say, "evacuate," don't question it. Pack up and go.

After Hurricane Hugo, a television news reporter visiting storm-ravaged McClellanville, South Carolina, interviewed a woman who had failed to evacuate. McClellanville took perhaps the full brunt of this gargantuan storm. The woman

and her family had somehow managed to ride out the storm's 135-mile-per-hour winds and astounding 21-foot storm surge, barely escaping death.

"Will you evacuate the next time a storm approaches?" asked the interviewer.

The woman, still shaken by the experience and responding without thinking, accidentally chose the wrong word when she answered.

"Will I evaporate?" the woman replied breathlessly. "You bet I will. The next time the authorities say 'evaporate,' I'll *evaporate!*"

*June, too soon—July, go by; August, be cautious—September, REMEMBER!*

So goes the oft-told rhyme about hurricanes. Indeed, beginning in August, those who live anywhere near the coast need to keep a close eye on the tropics. Of all the statistics about hurricanes, perhaps the only one that follows any predictability is that more have hit in September than in any other month.

"Hardly a decade passes without a hurricane," wrote a visitor to the Georgia and South Carolina coasts, the Baron de Montlezun, in 1818. "It is noteworthy that those which blew up in the course of the last century occurred, without exception, during the first few days of September."

Where will Jurakan strike next? No one can predict it. Blowing trumpets into the air is probably as good a method as any to appease him and keep a storm away.

What we do know is that come September, the peak month for East Coast hurricane strikes, thoughts of "evaporation" cloud our thoughts with every tropical update. Whether Jurakan blows in or not, it is best to be prepared.

# The Hunley: Forerunner of The Silent Service

B RAVERY IS UPPERMOST IN MY mind as I consider the history of the CSS *Hunley*. Even in this day and age, it takes courage to do a job that requires underwater work. The men on the *Hunley* were, like Chuck Yeager, the test pilots of their time. They trained in Mount Pleasant for months prior to their voyage against the USS *Housatonic*, learning their vessel's intricacies and foibles and honing their skills as a team. They bunked together at an inn called Ronkin's Long Room, near present-day Alhambra Hall. For a time, they walked every day from Mount Pleasant to Breach Inlet, where they did practice dives in a vessel that some onlookers had dubbed the "coffin boat."

Theirs was no suicide mission. Like astronauts, they were on the threshold of discovery. This crew was determined that their mission would succeed. They had the right stuff—the daring and determination to break barriers. They were the first to test their vessel in the uncharted waters of inner space, the depths beneath the surface of the ocean.

When the *Hunley* sank the *Housatonic* on the night of February 17, 1864, it did more than make its mark in history as the first submarine to sink an enemy vessel. It introduced an entirely new form of strategic effectiveness—the submarine service. We take this military capability for granted now. Yet, over and over, it has proven to be essential to the security of the United States.

The submarine service—*the silent service*—is perhaps the most dangerous of all military services, no matter what the nation. The men on the *Hunley* were the first submariners to die for their country. They have not been the last. For, despite every possible safeguard, being a submariner is synonymous with hazardous duty.

I cut my teeth on stories of the submarine service. My storytellers were two noted submariners who served in the Pacific on the USS *Silversides* (SS-236), commissioned only eight days following the Japanese attack on Pearl Harbor. Creed Burlingame was the captain (later Admiral); his executive officer was Thomas D. Keegan, who later made captain. Both retired to Charleston at the end of their careers and were close friends of my parents. Both are now safe in that great port in the sky, but I remember their stories well.

The *Silversides* was an attack submarine that earned the distinction of sinking twenty-three enemy ships during its fourteen war patrols and is listed as third on the U.S. list of submarines for most sinkings. Robert Trumbull, in his 1945 book *Silversides*, describes the daring exploits of the ship and crew. One of the most dramatic, knuckle-biting stories involving the crew of the *Silversides* was even recreated on the 1950s television series, *Silent Service*, when an emergency appendectomy was performed on a crewmember—*while* they were being depth bombed by a Japanese destroyer. The *Silversides* had a number of close calls. There was the time they slipped through the submarine nets into an enemy harbor, right under the nose of the Japanese fleet. And, more than once, the submarine sat in complete silence, engines off, resting on the ocean floor—listening to the telltale *pings* of the sonar—praying that they would remain undetected by the Japanese destroyers searching for them on the surface. It took nerves of steel.

Like a typical sea dog, Creed Burlingame had a superstitious side. Each time they made a run he knew the odds were fifty-fifty that they might not return. At some point during the war someone brought aboard a small statue of Buddha. Both Burlingame and Keegan were good Christians, but every time they went into action, all crewmembers rubbed Buddha's belly for good luck. I remember one story about a crewmember who forgot to rub Buddha; the sub was attacked (when it surfaced) by enemy aircraft. Tragically, this crewmember was one of the few who was killed in service on the *Silversides*.

There is no doubt about the importance of the submarine service to the eventual outcome of World War II. Both in the Atlantic and in the Pacific, those then diesel-powered vessels were instrumental in keeping the waters safe for our surface ships. They operated in stealth and with cunning—an unseen, silent and strategic force beneath the sea. Now nuclear powered, they still do.

What surprised many when the *Hunley* was finally brought to the surface in August 2000, was its similarity in hull design to the modern submarine. What had started out basically as an old steam engine boiler became a streamlined submersible vessel with remarkably modern engineering. It had diving planes positioned much like the side fins on a fish. And although the *Hunley* was operated by a hand-cranked mechanism, it was originally designed to run on battery power. Its major flaw was not in its engineering, but perhaps in the fact that in the 1860s there was no magnetic compass that would operate within steel and underwater. Other than that, the *Hunley* was an invention truly ahead of its time.

When the world watched the *Hunley* resurface, we were not merely witnessing the retrieval of an historic Civil War relic, we were seeing the prototype for every modern submarine sailing the oceans today. They run silent; they run deep. And like the crewmembers of the *Hunley* and the *Silversides*, the sailors of these modern ships do so in ever-present danger. For this, I honor them.

To the crewmembers of the *Hunley* and to all who serve in the silent service, I quote Samuel Taylor Coleridge's *Rime of the Ancient Mariner*: "The fair breeze blew, the white foam flew, the furrow followed free. They were the first that ever burst, into the silent sea."

# August Light

Maybe I have already done it," ponders a character in William Faulkner's book *Light in August*. "Maybe it is no longer waiting to be done." August is here, my friends—that curious, pivotal and delicious time of the year when summer still reigns but we begin to feel the unmistakable touch of autumn. It shows in the sassafras leaves, which are beginning to change from green to russet and orange and fall in my backyard. It shows in the pecan trees, which are filled with large green, leathery nut pods. It shows in the fields and roadsides, where a month ago wildflowers were in full bloom but now are "thigh deep in dusty weeds." As we turn our thoughts from vacation trips and days on the beach to book bags and school clothes, we think, "Where has the time gone? Is it August already? But, it was just the Fourth of July!"

Yes, August is beginning to show. The seasons are beginning to turn. There is that unmistakable *something* in the air. And, more than anything, there is the August light. There is a distinct, airy and almost delicate quality about the light in August. The sun is beginning to nestle into its wintertime position, casting angular rays which diffuse and brighten the depth of the landscape of late summer green. The marshes, at the height of their maturity, shimmer and gleam, and the spartina moves in the wind like an undulating cape of emerald velvet. There is a mellowness that comes with August light. Faulkner described the August sun as "a prone and somnolent yellow cat" watching the "slow flowing of time" beneath him. Time does seem to flow more slowly in August, especially during those periods when it is unbearably hot. August appears to drag on interminably and its thirty-one days feel more like thirty-seven.

Augustus Caesar stole a day from February to give his namesake month of August thirty-one days. This decision was not based on any astronomical purpose but from simple petty jealousy. Augustus thought of this month as his "lucky" month, for it was in August that he scored his greatest military achievements and first became a consul of Rome. He didn't want July, which was named for his uncle, Julius Caesar, to be longer than the month that carried his own name.

August is a month of yellow days, days when the ocean border is commanded by tall, white cumulous clouds, which march across the tropical horizon like sentries at their post. When the early morning sky is washed with saffron and the light bleaches out darkness with the color of sand. When the late afternoon setting sun deepens the earth into shades of copper and orange, and the sky is fringed with sweeping cirrus clouds tinted with turquoise, ruby and sapphire.

The old ones called these clouds "mares' tails" and saw them as a sign of the approaching season of tropical storms. "Watch-em. Mares' tail fill de' sky," warned my friend, an Edisto Island Gullah fisherman who has long since gone to his heavenly home. "Mares' tail mean big storm a-comin'," he would sagely predict as he pointed to the cirrus clouds above. And sure enough, if it isn't a "hurricane bin come," whenever sweeping curls of mares' tails dominate the sky, some sort of tropical system usually passes through within the week.

August is the month of four o'clock thunderheads, forming in predictable mountains over the western horizon almost every afternoon. Charged with electricity and heavy with rain, they change the temperature from broiling to steamy and wreak havoc on the motorist during the rush-hour drive home.

August is the month of sweet, fleshy mountain tomatoes; of okra that has grown too large to be good for anything but stew. The month when blue crabs are at their fattest and saltwater fishing is at its best. When shrimp are plump and full, and the shrimp boats come into the harbor trailing a smog of seagulls hungrily diving, bobbing and working the wake as they feast on the leavings tossed aside.

August is a month of excesses. A time when days are too hot and storms are too fierce. When fogs of mosquitoes clog our twilight yards. When people with sanity decide to remain in their mountain cabins for "just one more week." When the rest of us wipe the sweat from our brows and yearn for September, hurricane season be damned. And, like Faulkner observed, August is the month when we ponder whether we did the things we set out to do, or whether they needed to be done in the first place. We go from "should I" to "did I" with a simple rotation of the earth's axis.

This is the month of August. It is bathed in exquisite, glimmering light with days awash in the colors of lemon and cream. It is a time when we see the summer crops come to their peak, and then pass on. It is a month of Sundays, when we can almost feel and touch time as it makes its steady and unwavering advance toward autumn. August. Yes, this is August.

# Close Encounters of a Nevisian Kind

I HAVE BEEN IN CONTACT WITH a Nevisian. This is not to be confused with a Kittitian, although they are close neighbors. No, I have not been beamed into an alien world by Scotty (although my particular Nevisian connection has a bit of an other-worldly side), and yes, I am still in South Carolina. Moreover, my present encounter is not the first time in history that Nevisians and Carolinians have associated.

In fact, the historical connection goes back to 1669 and the ship *Carolina*, bound for the New World to establish the Carolina colony. Aboard were about one hundred people, mostly English, who would sire those who would eventually be known by the curious appellation, *Charlestonian*.

The trip from England to Carolina for those first colonists was a long and arduous one. As the voyage progressed they encountered not one hurricane, but two. They were short on water and food. Seasickness plagued passengers and crew. And they were about to become strangers in a strange and unknown land.

After months at sea the colonists reached Barbados where they took on supplies and refitted their storm-wrecked vessel. Sailing on, their next stop was a tiny island in the Leeward chain, a mere 36-square mile, oval-shaped dot bordering the northeastern curve of the Caribbean Sea. The island's most distinguishing feature was its mountain, which rose from the middle of the island to a lofty 3,232 feet above the sea.

The Carib Indians had called this island Oualie (pronounced "oo-a-lee"), but by the time the *Carolina* arrived, these original inhabitants were mostly gone—no thanks to the arrival of the Spanish, and later, the English. In fact, it was Columbus

who first discovered the island in 1493, naming it *Santa Maria de las Nieves* (*nieves* being the Spanish word for snow). Columbus had incorrectly decided that the island's mountaintop, which is characteristically shrouded in clouds, was covered with the frozen white stuff. So much for Chris's knowledge of Caribbean climes.

His mistake, however, gave the island its name—Nevis—and gave its inhabitants (who comprised, at various times, Spaniards, English, Dutch, French, Africans and no doubt a goodly number of pirates), their designation as Nevisians. The Nevisians, who greeted the sea-weary souls on the *Carolina* in 1669, were English colonial sugar planters. The island had been settled in 1628 by the English from the nearby island of St. Christopher, later to be known as St. Kitts. Those who live on St. Kitts are called Kittitians. Gesundheit!

These early British Nevisians eventually built coastal towns with names like "Charles Town" (sound familiar?) and, as Anglicans, established a parish system almost identical to the one later created in South Carolina in 1707. The names of their parishes read like a page from a South Carolina history book—St. James, St. Paul, St. Thomas, St. John and St. George. Their parish names, however, are a bit more fanciful than ours. We may have a St. James Santee, but they have St. James Windward, not to mention St. John Fig Tree, St. Thomas Lowland, and St. George Gingerland.

Being an early English colony is not the only connection Nevisians share with Carolinians. The inhabitants of both places also experience those pesky little whirlwinds called hurricanes. Nevis just gets hit by the storm before we do. It was during a summer storm season that I came to meet my Nevisian friends, Professor Peter "Batten Down the Hatches" Crane and his good wife, Eugenie. We met through StormCarib, the on-line Caribbean Hurricane Network of which Professor Crane is the Nevis contact.

Most of the correspondents of StormCarib take their responsibility as hurricane watchers very seriously. Well they should, for they are on small islands sitting in the path of tremendous storms. Professor Crane is quite well informed. Yet his reports are . . . how shall I put it? *Different.*

Consider his report made after the island had received an unusually hard rain: "This morning as I was quietly sitting on the gallery, nibbling a few mushrooms, a most strange ship sailed by. How to describe it? Well, although I cannot be EXACT, you understand, it had a length of approximately three hundred cubits and was about fifty cubits wide! The captain hailed me as it passed but I couldn't quite catch his words . . . Was it raining? Yeah, of course it was and it is and it might rain for a bit longer. Regards, Prof. Peter 'Two-by-Two' Crane."

And then there was the time the power almost went out:

"I do not subscribe to the oft-repeated view that, on Nevis, we get a power cut if a dog barks. Oh no! I clearly remember a week ago when BOTH our dogs barked and we had electricity all that night. But Tropical Storm Chantal passed close to us last night and we had power ALL THROUGH. Well done, NEVLEC (Nevis

Electricity). Credit where credit is due, I always say. Regards, Prof. Peter 'Throw Away Those Candles' Crane."

And sometimes he even writes his report in poetry (or a semblance thereof):

> *This ain't very funny, and it sure ain't not sunny,*
> *But we're getting more water, than ever we oughter,*
> *And it's cold and it's wet and it's runny.*
> *Regards, Prof Peter 'Nobel Prize for Literature' Crane.*

I have thoroughly enjoyed my e-mail correspondence with Peter and Eugenie, although I have yet to find out whether they are Fig Tree Nevisians, Gingerland Nevisians, or Lowland Nevisians. Some things, I suppose, are best left unsaid. The most recent missive I received, however, gave me pause for thought.

It seems that Eugenie hurt herself transplanting some papaya trees. She tripped on a rock and fell headlong down the slope, whereupon she was met by their two dogs who immediately licked her in the face. I happened to read this account as I was shivering to a very unfunny, not sunny, unusually cold and runny day.

A close encounter with a fresh papaya in a tropical setting sounds just about right. So I say, "Beam me up, Scotty!" The Nevisians await!

# The Great Charleston Earthquake of 1886

I ONCE LIVED IN A LOVELY single house in downtown Charleston, complete with piazzas, a walled garden and a chandelier hanging in the formal dining room. The house had been erected in the 1840s and a friend of mine, an inveterate bottle collector, suggested we dig the privy and see what we could find. For those of you who have not had the pleasure of antique collecting in this unique fashion, a word about old privies. Prior to organized garbage collection, the deep hole of the outhouse privy was also the place to discard such things as old inkwells, wine and medicine bottles. Today, these items can be highly collectible and, if one is lucky, digging an old privy can be like hitting pay dirt, if you'll pardon the pun.

By the way, after a century or so, the organic matter left in a privy is only dirt. Digging one is not as disgusting as it sounds.

Unless you're digging one like mine, which was located under a later addition built onto the rear of the house. Digging this privy was no easy task. We only had about a three-foot crawl space in which to work. Before it was over I felt like a tunneler in the movie *The Great Escape*.

Sure, we found bottles—lots of them! We also discovered something far more interesting. About three feet into the hole, we hit a solid layer of broken plaster pieces. Under this, we found about a dozen broken glasses, stacked just as they would have been in the cabinet, one atop the other. Next we uncovered about two-dozen broken dinner plates. Then came broken crockery, fine porcelain and heavy clay cookware. What was this? It looked as if they'd thrown the entire kitchen away, all at one time, walls and ceiling included.

My friend was disappointed with so many broken treasures and not one worth keeping. But I was elated! I suddenly realized that I was seeing, up close and personal and for the first time in a hundred years, physical evidence of the destruction wreaked by the Great Earthquake of 1886. Yes, they'd thrown the entire kitchen away—and probably a good portion of the house, as well.

At approximately 9:50 p.m. on the evening of August 31, 1886, residents of Charleston and the surrounding area were literally jolted into a sudden new reality when the earth moved, violently—not once but five times. The earthquake began with a low rumble and increased until it hit the crescendo of a thundering roar. Walls caved in; ceilings fell. Buildings collapsed. In some areas, the sandy soil liquefied into a quivering mass of quicksand-like fluid. Open fissures gaped, emitting the strong, steaming odor of sulfur. Fires erupted throughout the city. In almost an instant, virtually every house and building in Charleston suffered some sort of damage. About 6,000 buildings were severely damaged or destroyed. Approximately 110 people were killed. Untold numbers were injured. In a word, the results were catastrophic.

"The City is wrecked," reported the *News & Courier*, which somehow managed to get out a paper the following morning. "Streets are encumbered with masses of fallen bricks and tangled telegraph and telephone wires, and up to an early hour it was almost impossible to pass from one part of the city to another. The first shock was followed by a second and third, less severe than the first. The air was filled with the cries and shrieks of women and children . . . 'God help us! . . . God Save us!' It was worse than the worst battle of the war." The city suffered a total of five shocks that night, and although they diminished in violence, each caused powerful damage.

The following morning found the city in ruins. City Hall and the Courthouse were so badly demolished the mayor and council had to meet elsewhere. The old stationhouse, located at the corner of Broad and Meeting Streets (where the Post Office is now), was in an irreparable state of wreckage. The Corinthian columns of the portico at Hibernian Hall lay in a pile of rubble.

What the earthquake had not damaged, the ensuing fires had. That summer had been abnormally hot and dry, causing drought conditions. When the fires erupted (almost all simultaneously), despite truly heroic efforts, there were too few engines and insufficient water to put the fires out.

From Bull's Bay on the pilot boat *Wild Cat*, Captain James M. Lee later reported that the shock broke the bulkhead, and the cattle on the island "bellowed out at a fearful rate," and they could see the fires in the Charleston vicinity. The whole city appeared to be in flames.

Understandably, the quake caused chaos and pandemonium. People fled the falling bricks and unstable buildings and took to the streets. "The world seemed to come to an end," remembered Miss Sue Miles of Summerville, also hit hard by the quake. "Terrifying noise, darkness, all lamps blew out, fell on the floor. A

fearful noise, the house in motion, crashing destruction . . . the most hopeless feeling of terror seized us."

In the ensuing days, Charleston's beautiful parks became tent cities, filled with people from all social and economic backgrounds, who were either homeless or unable or afraid to re-enter their damaged homes. They had good reason, for a string of aftershocks of varying strengths followed, the last one occurring as late as September 30, one entire month later.

"Half of the people in the town are out in the streets or squares with sheets or table clothes for tent coverings," wrote Augustus T. Smythe in a letter dated a week after the earthquake, adding, "Mrs. Elliott Welch had twins in a tent out on the Battery two nights ago. There have been several births in tents."

Once again, Charleston faced disaster head-on. The previous year, almost to the day, the city had suffered the devastating effects of a killer hurricane. Known in history as the "August Cyclone of 1885," the storm was Hugo-sized with extreme winds and major flooding. Also, Charleston had yet to recover from the economic depression caused by the Civil War.

"A year ago," reported the *Courier*, "a considerable part of the loss fell upon corporations and wealthy firms who were enable to endure it. There is now a totally different condition. Every home in Charleston is injured more or less, and every householder, however humble his circumstances, must find the means of repairing his house." This was a trying circumstance for many residents, and they were forced to rely on the charity of their neighbors and friends. Augustus Smythe wrote, "I got $250 today for the Misses Gibbes, from a private source so their names will not go before a public Committee . . . Poor old Mrs. Dawson who lived near Friend St. . . . and her daughter had to leave their house, which is unsafe . . . they had nothing to eat, and all their little belongings are up in their house, and it is considered risky to go into it. I am carrying them some money today to relieve their immediate wants." Within the month, financial aid came pouring into Charleston from across the United States and the world. Charleston, the perpetual phoenix, began slowly to rise from the ashes.

The following eyewitness account of the earthquake on Sullivan's Island appeared in the *News & Courrier*:

*The shock on Sullivan's Island was preceded by a low, wailing sound which gradually grew heavier and louder until with a roaring sound houses were thrown violently from side to side . . . The scene at the Moultrie House . . . was one of intense confusion and fright. A large number of ladies and children boarded there in addition to a large number of young people who had come to enjoy the hop to be given there on Thursday evening. Not more than three dances had been gone through with when above the strains of the band, came the now familiar and much-dreaded low rumbling noise. Everyone stopped instantaneously to listen to the curious noise. Five seconds after the house rocked so violently that for a moment it was doubtful if the house would stand. The timbers creaked and groaned and the ladies and children cried out at the top of their voices, rendering it difficult for the*

*gentlemen to make them understand that the danger was over. Hardly had they succeeded in quieting them when the second shock came, followed closely by a third, which again caused the ladies to become unmanageable. The streets from the Perry Company's wharves to the Bowen residence were filled by people encamped there including old men and ladies, young boys and girls and children, and babies in the arms of their mothers or nurses. When the shocks were over everybody quieted down and soon children were asleep, watched over by loving eyes. Perhaps the most remarkable feature of the earthquake on the Island was that not a single person was injured, with the exception of Miss O'Connell, whose ankle was badly sprained in getting out of the house. The damage to the residences was confined to the destruction of a few chimneys and ceilings.*

Similar events in Mount Pleasant were described in the *News & Courier*:

*Dreadful rumbling noises were heard everywhere, accompanied with strong shaking of the earth. The homes, which are mostly wooden structures, were shaken like reeds by the wind. Their rocking to and fro threw the furniture about the house, breaking much of it and smashing all glassware and crockery. The chimneys were torn from most of the buildings and thrown about the yards in every different direction. No houses were thrown down anywhere in the village.*

*Just back of the new German church there is a large sink which the previous day was perfectly dry. On Wednesday morning it was full of fresh water. Near Shem Creek . . . yawning chasms extending through the earth's surface for ten feet and over. All around this there are sinks of fresh water and masses of mud with queer looking soft substances which have never been seen before . . . contended by many . . . to be volcanic matter. Just after the first great shock . . . there was a decided and distinct smell of escaping sulfuric acid over the entire village. This smell lasted through the night and was distinct yesterday morning in those localities where . . . cavities in the earth were more numerous..*

Before this tremendous earthquake in 1886, Charleston experienced somewhat frequent earthquakes of varying magnitudes. Some of the most significant I've come across in my research are:

| | |
|---|---|
| May 19,1754 | Very slight |
| November 26,1777 | Mentioned by Henry Laurens as "a pretty smart shock" |
| April 4,1799 | Violent |
| November 12, 1799 | Accompanied by meteors in great numbers |
| September 10, 1811 | Shock |
| December 16, 1811 | Violent and repeated shocks |
| January 24,1812 | Six slight shocks; comet visible |
| February 4, 1812 | Two slight shocks |
| August 23, 1812 | Attended by a great meteor |
| February 7, 1843 | Shocks, rumbling and hissing sounds |
| December 19, 1857 | Several slight shocks |
| January 19,1860 | Mentioned in Jacob Schirmer's diary as "a severe shock." |

# The Pond

THE DRAGONFLY, WITH TRANSLUCENT WINGS glistening blue neon in the sun, hovers just above the water's surface, scrutinizing a skidding feather propelled by a gentle breeze. Nearby, three turtles nap atop a log, looking like large brown cobblestones placed according to size. The water below is clear. Tiny minnows dart amidst long tentacles of green algae. There, in the silent, liquid sanctuary of his domain, a bass glides by, dominant, aloof and disdainful. He cares not a whit about the turtles, the dragonfly or the feather. Things above are beneath him. His every movement is carefully controlled, guided by the deft and barely noticeable swish of a fin.

The pond is small, as bodies of water go. It began as a man-made borrow pit relatively the same size as the nearby parking lot its earth helped build. It is a young pond, not more than ten years old, and it borders a business park in a newly developed area of Daniel Island. Yet nature is so tenacious in this part of the world that what began as a hole in the ground has already evolved into a fertile, independent ecosystem.

A verdant and vigorous arrangement of vegetation now borders the pond. Cattails and clumps of duckweed join overhanging water oaks and thickets of myrtle in early spring green. Two young cypress trees have taken root—long-legged teenagers with bases only just beginning to thicken out and create knees. Tall flags of lavender water iris bring a dash of color and thoughts of Monet.

The wind stirs and, from the corner of my eye I discern a slight movement from the pond's distant shore, a barely detectable swirl. A fish perhaps? Another turtle?

But no, the small head pops up, high and purposeful. The snake begins to scissor its way across the shallows, hugging the edge of the pond. It stops, raises its head

as if to get its bearings, and continues on. It knows what it is doing. It sidles its way along the water's edge until it has completed an almost total circumference of the pond. It reaches the floating duckweed in the shallows some eight feet below where I am standing, then glides onto the tangle of green and stops. It doesn't move.

Then, as if from nowhere, another snake suddenly appears in the middle of the pond, slithering atop the water's surface, also heading toward the duckweed at my feet. I spy another undulating ribbon moving amidst the cattails on the far bank, sliding into the water. I see yet another snake racing from the farthest shore across the top of the water with gathering speed.

Four snakes! A snake convention, I think, and stare at the sleek dark back of the snake below me, lying motionless on the duckweed. I can see the snake's markings clearly. It is not a water moccasin. There is no broad, arrow-shaped head. It is just a black water snake, nonpoisonous, a beautiful creature. It is long, about three feet, and its scales glisten in the watery sunlight.

For some reason the other snakes have stopped their progress toward my bank and are now aimlessly darting across the pond's surface. Have they seen me? Has my presence interfered with the primordial order of this natural habitat and stopped them, made them afraid to proceed? Or are they simply performing some rite of snakedom, a type of aquatic snake ballet? I am enchanted by this sudden influx of snakes. I am watching four snakes darting and slithering across a pond that is within a stone's throw of offices and computers and fax machines talking to offices, computers and fax machines in other countries. I have never seen so many snakes in the water at one time.

Ah, but I think, it is spring, after all. The time when big snakes get together to make love—and little snakes.

Is the snake lying dormant beneath me the lady snake, I wonder? Are the snakes dancing across the surface of the pond the boy snakes, showing off for the lady, strutting their stuff, vying for her attention? If so, she seems completely uninterested. In fact, she appears to be asleep.

Suddenly, a dark shadow appears on the pond and above me I hear the "kreee" of an osprey. I look up, shielding my eyes from the sun, and see the outline of the bird's wings spread wide as it soars overhead at treetop level. "Kreee!" it calls again and this time, I hear a second, echoing "kreee," the voice of its mate calling back. The two ospreys glide by, forming twin shadows on the pond's surface before they fly away.

I look for the snakes. They are gone. Even the snake at my feet has disappeared.

I smile. *There is no such thing as a free lunch,* I think. It is why I am here, working in an office. I turn and go back inside to work.

# Hurricane Hugo

T HE WIND BEGAN TO RISE significantly about four o'clock on the afternoon of September 21, 1989. By then, the house was battened down, the windows boarded up and everything humanly possible had been done to protect the house during the storm. The only thing left to do was cook while there was still electricity, and wait. I poured myself a stiff scotch, fed the dogs and cats, and took what would be the last warm shower for a long time. I then cleaned out the tub and filled it with water.

By six o'clock, the tops of the trees were being lashed into low bends by sudden gusts. Gray, scudding clouds were whipping in, one after another, from the east. I went outside and could distinctly hear the roar of the surf on Sullivan's Island, although I live inland, two miles away. The sun broke through at sunset, casting the sky in an eerie, menacing reddish-orange, more the color of copper, with tinges of green.

By eight o'clock, the driving rains had come in force, carried by winds now so strong that the drops flew by sideways, and stung like buckshot on the skin.

By nine, the electricity was gone. Outside, the night was literally howling—a turbulent combination of 100 mile-per-hour winds and the steady, insistent roar of constant thunder and torrential rain. Flashes of lightning illuminated a wild sky where clouds whipped by so fast they were difficult to track. Twice I saw the luminous greens, reds and yellows of St. Elmo's fire.

By ten, the wind was screaming from the east. It was too dangerous to venture out for any more peeks at the storm. From this point on its ferocity was measured by sounds—the sickening moan of a tree being pulled from its roots and the

startling shotgun—POW!—of a snapping limb, which would then fly wild and savagely slam into the side of the house. There was the skin-crawling, blackboard screech of a neighbor's tin roof being curled back from its foundation. I huddled on the couch with my dogs, scared but safe. Out there in the blackness, I knew the ocean—now a broiling, seething mass of savage foam and brutal waves—was beginning to steadily encroach upon the land with the rising tide.

By eleven, the full force of this killer storm was wreaking magnificent destruction throughout the entire Lowcountry. Houses collapsed, their walls falling from the strain of holding up against the shrieking winds, now constant in the 130 mile-per-hour range. Pressure exploded windows and blew out doors. Tornadoes roared unpredictably through neighborhoods, indiscriminately tearing one house to pieces, leaving the neighboring house intact. Occasional gusts, which I later heard approached 200 miles per hour, were playing out their own horror shows.

The decibel level outside was now one continuous scream howling right over our heads—a continuous, high-pitched whine fused with the thunderous growl of a freight train. The cats, previously asleep, awoke and began to howl from the low pressure hurting their ears. One went wild, clawing and scratching in panic as it tried to climb the wall. I checked the barometer. It registered 28.1, the lowest I'd ever seen. The needle pointed to the word "hurricane."

And then—calm. At 11:50 p.m., the eye passed directly overhead. We ventured outside to survey the damage, joining a stunned group of neighbors who had also stayed to weather the storm at home.

Despite the ferocity of the previous hours, the damage on my street appeared to be slight and manageable. Trees were down, of course, and the street was a mess of leaves, limbs and debris. A few roofs were missing pieces and parts. But the thing we had feared most—the rising sea and a predicted tidal surge of 28 feet—had not occurred. Above, the sky was clear and stars were glimmering safely in the heavens.

Then, a fresh gust came. It was followed by another, then another and the big winds came on again, now from the west. We each ran inside, back to the safety of our dwellings, and prepared for the second half of the storm.

It was the fiercest half. For with the redoubled, knockout blows of the wind, now from the west, came the feared tidal surge from the sea—an insistent, unstoppable wall, oblivious to everything in its path.

We learned later that this huge force of water picked up everything from 20-foot sailboats to 200-ton shrimp boats, and tossed them cruelly onto land in splintered pieces. On the beaches, the waves sucked houses neatly off their foundations and carried them out to sea, leaving not a board or plank behind. Some houses were picked up, complete, and moved a block or two, or placed cockeyed in the middle of the road. Others became only the skeletal remains of what had once been substantial two-story dwellings. Incredibly, others (mine included) would escape with hardly a scratch.

The following morning, we joined other people, in varying states of shock, as we picked through the devastation, awe-struck and wide-eyed, not fully comprehending the full extent of the destruction or the massive task of clean up before us. The wind had blown all the leaves off the trees, giving the landscape a stark, Vermont-in-winter appearance. Even the evergreens, which never shed leaves, had been denuded by the unrelenting winds. Streets had become choked with impassable barriers of fallen trees, boats, soggy mattresses, furniture and unidentifiable pieces of houses.

There was no electricity, of course. Some would be without power for more than a month. We had water and, somehow, the telephone never completely quit working, even during the height of the storm. Yet, that morning after Hugo, we knew our lives would never be quite the same again.

If anyone ever doubted the basic integrity of the people who live in the Lowcountry, such thoughts were banished in the aftermath of the storm.

"How'd you come out?" a stranger would ask another stranger. "You-all okay?"

"Well, we lost the house, of course. A tree took the roof and the rains got the rest of it. But we're safe, and thank God, we're alive. How about you? Anything I can do to help?"

Somehow, the Bi-Lo on Ben Sawyer Boulevard managed to open, but without power. Inside, it was dark and unnaturally quiet as people searched the aisles with flashlights looking for the goods they needed. Stealing? Not here. Shopping was done on the honor system. As you walked in you were given a crayon to mark the price down on each item you selected. Then, after standing patiently in a long line at the register (which didn't work without power), the clerk added up your crayoned-in prices on a hand-held calculator and made change from a cigar box.

The next months were ones of never-ending clean up, executed to the rasping whines of chain saws and a sky filled with the incessant, clattering racket of emergency helicopters. Streets became canyons framed by six- and seven-foot walls of debris. Neighborhoods took on a circus-like appearance, with almost every roof wreathed in a garish of blue plastic while it awaited the much sought-after roofer.

With so many houses damaged or without electricity, the most popular place in town became the laundromat. Here, strangers became immediate friends, with stories swapped about their individual experiences and offers of help given, and appreciated. The positive outlook continued to prevail. "Sure, it's inconvenient to do the washing here," grinned one indomitable soul. "But it beats taking the laundry down to the river and beating it on a rock."

Twenty-six people died in South Carolina as a result of Hurricane Hugo. Damage was estimated at over $4 billion and an estimated 65,000 people were forced out of their homes and into temporary lodgings, many for as long as a year. It took less than twelve hours for Hugo to wreak almost total destruction on the Lowcountry. It took over two years to rebuild.

# Oyster Roast

IN VERMONT, THE LEAVES TURN. In Colorado, there is the first snowfall. And in Lowcountry South Carolina, you can tell it is autumn by the smell of wood smoke on a Saturday night, coming from the fire of the season's first oyster roast. It is a rite of passage, the signal for the advent of winter, and it is an event as old as the Lowcountry creeks from which the oysters come.

As early as 2000 BC, the coastal Indians were using oysters as food, and the ceremonial shell rings and shell middens that were left behind, composed mainly of oyster shells, are testimony to the huge numbers of these tasty bivalves the Indians likely consumed. At one time, shell rings dotted the entire coastal area. (They were later depleted by the early colonists who used the to build roads and to make lime.) Most rings were small, but two that still remain are huge; the shell ring at Fig Island near Edisto is 250 feet in diameter and contains an estimated volume of 375,000 bushels of shells. The Great Sewee Shell Ring near Awendaw is 300 feet in diameter, 40 feet wide and 9 feet thick. That's a lot of oyster roasts.

The irregularly shaped, hard-shelled bivalves called oysters (*Crassostrea virginica*) live in colonies along almost every salt creek in the Lowcountry. Despite the oyster's thick, razor-sharp shell, it is easy prey for numerous enemies. Star fish, crabs, flatworms, oyster drills and borers all find the oyster as delicious as man does. Oystercatchers, sea ducks and other birds feed on them, and they are a favorite meal for raccoons, otters and minks. The adage "only eat oysters in months containing the letter R" is followed—not because oysters produce any harmful poisons in warm months, but because they reproduce in the summer. Consequently, oysters are legally harvested only during the cooler fall and winter months.

The oyster roast as a social affair has long been a part of Lowcountry culture. As early as the sixteenth century, Spanish explorers were attending oyster roasts with the Edisto Indians. "They lighted great fires," wrote Pedro Mendendez de Aviles in 1657, "and brought many shellfish . . . Many Indians laden with corn, cooked and roasted fish, oysters, and many acorns." One of the most descriptive accounts of an oyster roast was written by I. Jenkins Mikell in his 1923 book *Rumbling of the Chariot Wheels*, recounting his days growing up on an Edisto Island plantation in the 1850s. By his telling, the roast was a lavish affair.

*As the guests seated themselves, at each place was an individual plate mat of coarse linen to hold the wooden platters of oysters, an oyster cloth on the left, an oyster knife, with protective guards, on the right. First came the butler, with a silver pitcher of steaming hot punch, filling the glasses; hot, old-time-knock-down-drag-out whisky punch; not your Manhattan or Bronx poison, but punch made of lemons, hot water, sugar and double-proof imported Irish peat whiskey . . . The host arose and inclined his grand old classic head. Then lifting his glass he simply said: 'To our kinsfolk, our guests—welcome!' At which point the platters were filled with hot oysters, and for a time nothing was heard save the knife struggling with an obdurate oyster.*

At about this same time, there was also a popular restaurant and oyster bar in Charleston called The Tivoli. Located on Meeting Street, it boasted having "The best **OYSTERS** supplied by the dozen, plate, quart, gallon or bushel, in shells, or pickled to order."

Somehow, The Tivoli survived the devastation caused by the Civil War relatively unscathed. The January 16, 1865 *Courier* announced: "The Tivoli— Old Place and Resort, Continues its supply of Oysters, which challenge and defy competition with any Oysters offered in this city or vicinity." On March 31, 1865, the *Courier* noted, "We are glad to learn that this old and popular resort on Meeting-street . . . has been re-opened by its former favorite proprietor Mr. Thos. McManus. Oysters will be served up as usual in Mc's best style, and every effort made to give satisfaction."

Which goes to show that the Yankees could hold Charleston under siege for two years—bomb it, burn parts of it and, finally, overrun it. But when all else failed, the 'obdurate' oyster prevailed.

# A Haunting on Queen Street

I WAS JUST EIGHTEEN AND IN my first year of college in Charlotte when my sister called and asked me if I would like to come down to Charleston and baby-sit while she and her husband went out of town for the weekend. As always, I jumped at the chance to come home to the Lowcountry. Also, they had just moved into a new home, a rambling, three-story house on Queen Street, which I had not seen yet.

I arrived on Friday afternoon. It was October and the air was crisp, just cool enough for a sweater at night. I had hardly gotten my things out of the car, brought my things into the house and greeted my family when there was a knock at the door. It was a dear, little old lady, a neighbor making her obligatory newcomer's call. As she presented her tin of welcome cookies, she peered over my sister's shoulder, obviously waiting for an invitation to come in, curious to see how her new neighbors lived.

The three of us sat in the living room—a formal setting—and I remember sitting erect and ladylike perched on the edge of a chair, sipping a glass of sherry and smiling politely as the lady and my sister made conversation. I was only half-listening as the lady prattled on about the previous owners of the house and gently gossiped about other neighbors. I perked up, however, when she pointed a delicate hand to the room upstairs, right above the living room, and said in a knowing, serious tone, "And *that's* where George died, poor old thing."

Whoa! She was pointing to the bedroom where I was to sleep that evening. All I could think of was who was George, when did he die . . . and how?

I never found out. My sister was too polite to ask and the lady didn't offer any further explanation. She left shortly thereafter and was barely out the door when

my brother-in-law came home. He and my sister had a long road trip ahead of them and were in a hurry to leave. In short order, I was alone in the house with my nine-year-old nephew, seven-year-old niece and an ancient, white-faced Golden Retriever named Rip.

The children and dog were playing outside, so I went exploring. The house was a Charleston single house built in the early 1800s and similar to the one in which I was raised, so I knew the floor plan. The typical single house is only one room wide and, usually, three stories high. From the side piazza, the front door opens into a central hallway flanked by a formal living room on the left and dining room on the right. This house was no different, except that behind the dining room, there was a den followed by a kitchen and pantry. From the central hall, a semicircular staircase with polished heart-pine flooring and mahogany railing wound its way upstairs. I started up, noticing that the second tread emitted a conspicuous creak when stepped upon.

The second floor was a mirror of the first, only the two rooms on either side of the hall were bedrooms. My oldest niece had the bedroom facing the street and, since she was spending the weekend with a friend, this was to be my room. This was also the room where poor George ostensibly met his demise. I shivered at the thought and entered the bedroom on the other side of the hall. This was the master bedroom, the centerpiece of which was a large, four-poster mahogany bed. The third floor also had two bedrooms, one for my youngest niece and the other for my two nephews, the oldest who was away at school.

All the rooms were large and had high ceilings, with hand-carved moldings over the door and window frames. Downstairs, crystal chandeliers hung in the central hall and over the dining room table. Outside, the piazzas overlooked a green-grassed garden protected by a high brick wall. It was, in a word, "Charleston."

The evening passed uneventfully. We ate dinner in the den watching Friday night television and playing countless games of "Go Fish" until ten, when the children went upstairs to their rooms on the third floor to bed. Rip was fast asleep, snoring peacefully by the couch. I rummaged around for a book and decided to go to bed myself. I locked the doors, turned off the lights, and went upstairs.

I entered what I now thought of as "George's room." It was probably only my imagination, but the room felt cold and uninviting and, frankly, I wasn't keen on sleeping in a room where I knew someone had died. Also, for some reason, I felt George's death had occurred fairly recently. I decided to sleep in the master bedroom.

I crawled up onto the massive bed and snuggled into the covers with my book. Eventually the laughter of the children upstairs diminished, followed by a silence that told me they were fast asleep. My eyelids were getting heavy, too, and I soon turned off the light and went to sleep.

I don't know what the time was but in the middle of the night I awoke with a start. I've always been a light sleeper and will wake at the slightest sound. I sat up

in bed and listened. There it was again! I distinctly heard the creak of the tread on the staircase. Was someone coming up the stairs?

The room was pitch black and I tried to adjust my eyes to the darkness. Had I remembered to lock the doors? Was this a burglar? If so, should I turn on the light and call out a "who's there?" Or was it better to stay put, keep quiet, and be protected by the darkness?

I heard another step. It wasn't really a full footstep, but more of a swishing, soft sound. Now fully alert, I strained to hear more. My ears were tingling; my eyes were as wide as saucers.

Then I heard the breathing.

There was no question, now. I could distinctly hear each soft, rustling footstep coming up the stairs, each footfall accompanied by a labored, exhausted and, yes, mournful breathing. The progress upwards was slow—painfully slow—each footfall attended by the unearthly sound of someone, or some *thing*, inhaling and exhaling with every step.

This was no burglar, I realized. The sounds I was hearing weren't even made by anything human.

I was truly alarmed now, so terrified I could hardly move. I sat in the dark room, immobile with fright, listening as the sighing and moaning of the breathing drew closer, as the whispering steps made their steady progress up the staircase. Whatever it was had passed the landing and was well up the second flight, almost to the upstairs hall and the entrance to my room.

My mind was racing. If this wasn't a burglar and, if what was coming up the stairs wasn't even human, what was it? It was then that I realized there was the distinct possibility that I was about to meet a ghost, face to face. *George.*

I wanted to scream, but found I had no voice. Frozen in place, my white-knuckled hands clutching the sheets, I heard the breathing get closer and closer until it reached the top of the stairs. My eyes had grown accustomed to the dark and I watched and waited, numbed by horror, fully expecting to see the outline of a figure silhouetted against the open door.

But as I heard the footsteps turn and enter the room, there was no one there.

There was only the sound of that labored, unnatural breathing, now so close to the bed that I could barely stand it. I could feel my adrenaline pumping, my whole body throbbing with rushing blood, my skin prickling with terror. I opened my mouth, this time resolved to scream as loud as I could when . . .

"*Thump!*" Whatever it was had fallen to the floor. "*Thump!*" Then . . .

*Scratch, scratch, scratch, scratch.* Then a long, exhausted sigh.

What? No longer scared out of my wits, I turned on the light and peered over the side of the bed. Gazing back at me with blinking eyes, blinded by the sudden light, was the white, moon face of Rip the dog. He was smiling sheepishly, as if apologizing for not coming up sooner to perform his dog-bound duty of sleeping by the bed and guarding his human.

A dog! My ghost was a dog! I began to chuckle, then I began to laugh until I was laughing so hard that tears were streaming down my eyes. "Rip!" I managed to say between hysterics. "You old dog! I thought you were a ghost. I thought you were George! You scared me silly!"

Rip simply smiled and unconcernedly began to lick various parts of his body with loud, obnoxious slurps. I didn't care. The only thing that mattered was that I was safe, Rip was safe, the children were safe and poor old George wasn't out a-haunting that night. I eventually went back to sleep but this time, I left the light on.

I have since been haunted by real ghosts. I have felt the cold, icy presence of something unknown and seen mysterious lights and unexplained glowings in the dark. And, yes, these occurrences have frightened me.

But in all my life, the most horrifying experience I've ever had, the only time I was absolutely terrified, was the night of the haunting on Queen Street—the night Rip the Dog ascended the stairs.

# Historic Fishing:
# Spot-tail Bass

W ITH SEPTEMBER COMES THE PEAK season for fishing in the Lowcountry, particularly surf fishing for red drum, also known as spot-tail bass. The red drum's scientific name is *Sciaenops oceallatus*, which, roughly translated, means a perch-like marine fish with an eye-like spot. This is one fish that goes by different names, depending on the region. In Florida and in the Gulf it is known as the "red fish" because of its copper-colored scales. In North Carolina, if a drum weighs less than fifteen pounds, it is known as a "puppy drum." In the Lowcountry, it is known as a channel bass or as a "spot-tail bass" for the dark spot (sometimes there are several) near its tail.

These fish can grow to an immense size, up to one hundred pounds, and fishing for them is great sport. One of the Lowcountry's great drum fishermen was William John Grayson, born in 1788 near Beaufort. Grayson was a brilliant man, a politician who had served in both the House and Senate, and was a nationally recognized poet and author. He was also an avid angler, a sport he learned in childhood. He had a passion for drum fishing and the following passage is from his autobiography, written just prior to his death in 1863.

*During the holiday times that I spent in the Country I learned the arts of fishing and shooting, at an early age, as all boys do in Carolina. At first my fishing was confined to minnows and a pack thread line with pin hooks. . . . Next I attempted yellow-tail and whiting. In due time I became initiated in the noble sport of drum fishing. Port Royal, or Broad River as it is locally called, is the favourite haunt of the drum. It is a large heavy fish, weighing fifty or sixty pounds and sometimes more. It makes a singular noise in Spring of the year like the tap of a drum, which*

*explains its name. The sound is heard distinctly from the bottom of the river at a depth of five or six fathoms. The fish afford excellent sport to the fisherman and no bad dish for the table.*

Even in Grayson's time, catches were notably smaller than in previous years. "It is supposed that like many other productions of the country they are not so numerous as formerly," he wrote. "It is certain that the largest number ever caught, as far as I have heard, was caught a half century ago. In this great success it was my fortune to have a share. With ten lines, from half ebb to low water, we took ninety-six great fish and when the sport was at an end the fish were biting as rapidly as before. Our bait gave out and we rowed away from the ground, in our loaded boat, unsated with the day's sport and eager to continue it."

Today, we have both size and catch limits to protect various species of fish, including spot-tail bass. While there were no catch limits in Grayson's day, the problem of over-fishing had already been recognized. As early as 1726, a law was passed in South Carolina to "Preserve the Navigation and Fishery in the Several Rivers and Creeks of this Province." This law basically provided that people could not dam up creeks and rivers in order to corral large quantities of fish. That wasn't all folks were doing to bring in big hauls in those early years. The act also made illegal "the pernicious practice of poisoning the creeks in order to catch great quantity of fish . . . by which means many fish . . . as well as the fry, are destroyed." The fine, if caught, was harsh: ten pounds current money for a free white man or a public whipping "not to exceed thirty-nine lashes" for a slave.

Thankfully, not all slaves were put in the unfortunate position of poisoning fish for the master's table. Some of the greatest early Carolina fishermen were African-Americans, men whose sole job on the plantation was to procure (legally, with hand line or rod) fish for the table. They were expert fishermen and, bondage notwithstanding, this had to be one terrific job, especially if one's master was General Charles Cotesworth Pinckney.

Born in 1746, we primarily know Pinckney as a Revolutionary War hero, a drafter of the United States Constitution and an 1800 Federalist candidate for President. Castle Pinckney in Charleston harbor was named in his honor. Among his landholdings was Pinckney Island, situated between Hilton Head and the mainland, where he had several cotton plantations. The waters surrounding the island offered excellent drum fishing.

Like most plantation owners, Pinckney was mostly an absentee owner. When he was in residence, however, he spent a good bit of his time toward the procurement of fish. Granted, he was not always the one to do the fishing, leaving the task to his plantation workers. Still, the catches were prodigious and important enough for him to record in his diary. The following is from this diary, written in April 1818.

*April 7th. Arrived at the Island about nine o'clock this morning. Sent the Boat a Drum fishing and caught 7 Drum. Gave a Drum to each of the overseers and one among the fishermen.*

*April 8th.  Sent the small yawl a fishing with George, Handy and Little Abram from the Old Place and York and Dago from the Crescent; they caught four dozen shrimps for bait last night and 14 Drum fish to-day.*

*April 9th.  Sent Captain Rogers of the Steamboat a Cauliflower, three white brocoli [sic] and a Drum fish.... Gave three to the fishermen and one to each of the overseers.  Twenty-three were in the whole caught.*

*April 10th.  The fishermen caught fourteen Drum . . .*

*April 11th.  The fisherman caught 15 Drum . . .*

So goes his diary until he leaves the island a little over a month later.  The boat went out daily but the fishermen changed weekly so that hands from each plantation had the opportunity to fish.  The fish were distributed among slaves, overseers and friends.  In all, Pinckney's fishermen caught 205 red drum.

Nice work, if you can get it.

# They Shore Do Talk Funny 'Round Here

A T A SOCIAL GATHERING ONCE, I had the pleasure of introducing a friend of mine, a man whose family is "old" Charleston to a group of people who are relatively new to the Charleston area. One of the first things newcomers to the Lowcountry notice is the distinctive accent found in parts of the Lowcountry. My Charleston friend speaks with what I call an "educated" Southern voice. It is a smooth voice, but has a hint of arrogance and a deep, commanding tone. There is a theatrical quality about the way he speaks and, at times, his delivery is downright Stentorian. You might say his voice is a masculine combination of liquid Southern and Richard Burton at his melodramatic best. My friend's voice, in keeping with his family background, is very much a voice of the Old South.

There are moments when the meeting between Old South and New South can make superb entertainment to the outsider looking in.

"You look terribly familiar," my friend said with characteristic grandiloquence after being introduced to one of the ladies at the party. "Are you, perhaps," he boomed, "a Ravenel?"

She looked back at him with an uncomprehending stare. She is originally from Vermont. Finally, pointing to her husband, she replied, "No, I'm riding with him."

Welcome to the South, my Vermonter friend. Down here, people don't just "talk," some of them elucidate. Or, as my cousin from the hills of North Carolina said during his last visit to the Lowcountry, "Yep, they shore do talk funny 'round here."

Indeed, to the outsider, Charleston can seem a place of unique peculiarities and nowhere is this more prevalent than in our various manners of speech—each of which can change according to whomever is doing the speaking. The Charleston

accent, referred to as Charlestonese, is a lyrical, almost Elizabethan brogue. Unlike the characteristic southern drawl, the Charleston accent shares similarities with that of tidewater Virginia and, in some respects, Boston. A car is spoken as "cyah;" Isle of Palms is pronounced "Oil of Pahms." Flowers grow in a "gyahden" and, after spending an afternoon working in one, a person might cool off by drinking a "bay-uh," or beer. And, if you have heard it but couldn't understand it, "nineteen eddy-yet" was the year before 1989.

The Charleston accent has apparently been distinctive for centuries. In 1774, St. George Tucker, the governor of Bermuda, visited Charleston and dryly noted that, "the local gentlewomen talked like Negroes." In fact, much of the speech of the Lowcountry white population, sometimes called Geechie, is drawn directly from Gullah, the speech of the original Lowcountry African-American population. Elements of Gullah are especially evident when it comes to our cuisine. We now think of gumbo as a stew, but the word is actually an African word for okra and a true gumbo uses okra as a main ingredient. One of our most popular dishes is she-crab soup, the name derived from the picturesque Gullah term for the female crab. And no matter what race, creed or color, a true Charlestonian calls a fish by only one name—"fush."

Gullah is a complex and intriguing tongue filled with colorful idiomatic phrases that make pictures out of words. "Dayclean" is the wonderfully descriptive Gullah word for daybreak. Witches and other evils that haunt the night are known as "boodaddies" and "boohags." A Gullah friend once told me about her recalcitrant son, a typical twenty-year-old who was spending all of his hard-earned money on girls. Like most his age, he was turning a deaf ear to his mother's advice. Still, she was philosophical about the eventual outcome. "De bird he fly'n high," she said sagely, "but he gwan come down to light soon. Yessum, das what bird do and dat be for true-true."

Since Gullah is often spoken at a rapid clip, it is sometimes difficult for the uninitiated to understand exactly what is being said. Even when you understand the words, unless you know the idioms you can get lost in Gullah phrase-making. When I was a child, my family had the happy occasion of receiving a surprise visit from our Gullah friend from Edisto, Edward Simmons. Back in those days, a trip from Edisto to Charleston was a rare and momentous event for an islander. My father was delighted to see Edward at our front door. "Come in, Edward!" he invited warmly. "How nice to see you!"

This is what Edward's response sounded like: "Icum wid me honna swing'n."

This is what Edward actually said: "I come with my hands a-swinging."

Only much later did another friend from Edisto translate the meaning behind Edward's cryptic announcement. Edward wasn't mad at my father and planning to take a punch at him. What he was saying was that he didn't have a suitcase (his hands were "swingin'") and wasn't planning on spending the night.

# Historic Food

How I miss the musical calls of the Gullah street vendors who used to sing out a lusty "wedge-a-TOBBLE!" as they hawked their vegetables down Charleston streets when I was a child in the 1950s. On Sullivan's Island, vegetables were sold by an elderly black gentleman from Rifle Range Road whose name, I believe, was Manigault, and who delivered his "wedge-a-tobbles" (the lyrical Gullah term for vegetables) from a mule-drawn cart, then later from the back of a rusty old pick-up. Manigault always had fresh tomatoes, okra, sweet corn and Sieva beans, those tiny, delicious butter beans that no self-respecting three o'clock Charleston dinner would be without.

A Sieva bean, (pronounced "sivvy") at least the name thereof, seems to be a uniquely Charleston invention. I searched dictionaries present and past but could find no such word as "sieva." A "sieve basket," one used for market produce and roughly approximating the size of a bushel basket, was used in England in earlier times. My bet is that, through the Gullah influence, the old English "sieve" became corrupted into the Lowcountry's "sivvy" bean.

Manigault's prices were always a bit higher than those on the mainland. When asked why, he'd explain, "you pays for the con-wenience." He was, after all, delivering his produce right to the kitchen door.

Springtime brings thoughts of putting ones own "wedge-a-tobbles" in the ground, a garden that will likely include both baby limas and tomatoes. While tomatoes have long been a staple of the Southern diet and are now perhaps one of the most popular vegetables today, they were not widely planted in most parts of America until the 1900s because people thought they were poisonous. This is partly

true, for the tomato is a member of the nightshade family. As someone reminded me recently, "don't eat the leaves." The red, succulent fruit, however is completely safe and has been a regular part of the Lowcountry diet since the 1700s.

Another southern staple is okra, a member of the cotton and hibiscus family. Even if you don't like to eat okra (heaven forbid!) the plant itself is an attractive addition to the garden, since it puts out a bright yellow bloom very similar to that of the tropical hibiscus. Perhaps no other dish epitomizes Lowcountry cooking more than stewed okra and tomatoes served over rice. In 1847 Charlestonian Sarah Rutledge wrote one of the first published cookbooks, *The Carolina Housewife*. Her recipe for stewed okra and tomatoes is called "Okra a la Daube." That's French for "Okra Stew." It is as valid now as it was in 1847:

*Twelve tomatoes (from which take out the seeds and express the juice); two slices of lean ham; two onions, sliced; two table-spoonfuls of lard. Fry in a pot until the onions are brown. Then add the juice expressed from the tomatoes, a gill of warm water, one table-spoonful of wheat flour, one quart of young okra (just cutting off the stalk end), and a little pepper and salt. Let the whole simmer on a very slow fire for three hours, observing that the okra does not get too dry. If it does, wet it sparingly with warm water, to prevent its burning.*

The early Carolina garden contained by necessity everything needed for the year's cooking. In 1682, an Englishman named T.A. Gent visited Charleston and wrote, "their Gardens begin to be supplied with such European Plants and Herbs as are necessary for the Kitchen, viz. Potatoes, Lettice, Coleworts, Parsnip, Turnip, Carrot and Reddish." Colewort was a general name for any plant of the cabbage family and from whence our popular dish called "coleslaw" originates.

Gent continued, "Their Provision which grows in the Field is chiefly Indian Corn, which produces a vast Increase yearly, yielding Two plentiful Harvests, of which they make wholesome Bread, and good Bisket." Indeed, cornbread is another staple of the Southern diet. Early gardeners were admirably creative when it came to the use of corn. Gent continued, "Of the Juice of the Corn, when green, the Spaniards with Chocolet, aromatiz'd with Spices, made a rare Drink of an excellent Delicacy . . . At Carolina they have lately invented a way of making with good sound Beer; but it's strong and heady."

Spirituous liquors have long been a part of the Lowcountry lifestyle (if you can't eat your vegetables, drink them) and in the seventeenth century, rum was a preferred beverage. Still, rum had to be imported and it didn't take long for colonists to start distilling their own special brands of firewater. In the 1760s, when itinerant Anglican minister Charles Woodmason set out to convert the heathens in the Upcountry, he found this love of liquid refreshment a roadblock to his proselytizing in Camden, then known as Pine-Tree Hill. After noting other debaucheries (the women didn't wear shoes!) he wrote, "now will come on their season of Festivity and Drunkenness . . . The Stills will be soon at Work to make

Whiskey and Peach Brandy—in this Article, both Presbyterians and Episcopals very charitably agree (Viz) That of getting Drunk."

Perhaps the most ingenious use of corn was by the early Indians. Gent wrote, "The Indians in Carolina parch the ripe Corn, then pound it to a Powder, putting it in a Leathern Bag: When they use it, they take a little quantity of the Powder in the Palms of their Hands, mixing it with the Water, and sup it off; with this they will travel several days."

This is the original, non-cooking method of making instant grits and if you're a northerner who already finds a heaping plate of grits anathema, I don't recommend the Indian recipe.

In the Lowcountry, grits are called "hominy" and have never been just for breakfast. Nothing makes a better Sunday supper than shrimp served atop grits. Contrary to popular belief, there is no difference between "hominy" and "grits." The best explanation I've heard of the distinction between the two was told by a Charleston lady of venerable age and impeccable family. The difference, she said, was simple. "Grits is what you buy at the store; hominy's what you call it when it is serve at the table."

One recipe that doesn't get much mention these days is the cooking of palmetto cabbage. An early name for the palmetto tree was the "cabbage tree" and apparently the tree was used for more than defending Fort Moultrie against the British in 1776. "To Dress Palmetto Cabbage," instructs Mrs. Rutledge in *The Carolina Housewife*, "Trim off carefully the hard folds of the palmetto cabbage; then boil the inner part for two hours, during which period the water must be changed three times, that the bitter quality of the cabbage may be entirely extracted. When the cabbage is quite soft, pour off the water, and mash the vegetable up with a wood or silver spoon; then add a large spoonful of fresh butter, and a little pepper and salt, and replace the saucepan on the fire for a few moments . . . To the above a gill of cream is an improvement."

It has often been said that a true Charlestonian is born with a silver spoon in his mouth. Now we know why. It was for mashing palmetto cabbage.

And don't forget, drink your vegetables.

# Buffleheads & Christmas

WALKING MOUNT PLEASANT'S OLD BRIDGE one cold December morning, bundled up against the cold and dodging intermittent showers, I watched as the east wind carried a lowering, pewter-walled squall line across the marsh and over Charleston harbor. It was a true Lowcountry winter's day—a proverbial "good day for ducks." Enjoying the sodden chill with full intensity were seven Bufflehead ducks that were frolicking and feeding in the marshland sea created by the unusually high, full moon tides.

I love Buffleheads. These compact, black-and-white divers are relatively people-friendly and you can almost always see a group around the rocks at the lower end of Sullivan's Island in front of Fort Moultrie. They like the little saltwater pond off Coleman Boulevard just before the intersection leading to Patriots Point and they particularly enjoy the marshland waters around the Old Bridge. Usually seen in groups of five or seven, they are easily recognized by the large, white circles on each side of the drake's head.

Originally called "The Buffel's Head Duck" ("buffle" being an archaic word for "buffalo"), the eighteenth century explorer and naturalist, Marc Catesby, described them aptly: "The whole head is adorned with long loose feathers elegantly blended with blue, green and purple . . . The length and looseness of these feathers make the head appear bigger than it is, which seems to have given it the name buffel's head, that animal's head appearing very big by its being covered with very thick long hair."

Like other migrating waterfowl, Buffleheads begin making their appearance along our shores in late October and November. Some ducks simply pass by us

and continue flying farther south, but Buffleheads apparently find our climate and food availability just to their liking and spend their winters here.

As I watched these little ducks against the backdrop of ocher-tinted marsh on one side and the gray fortress walls of Fort Sumter standing in the harbor on the other, I thought, "What constancy." More than likely, these ducks are the same group I saw last year and the year before. Likewise, because of that elusively understood element called genetic memory—that instinctive homing device which brings migratory birds back to the same locale season after season—I suddenly realized that it might even be possible that the ancestors of these ducks may have wintered in this very same spot centuries ago. They might have been the ducks seen by General William Moultrie on his way to Fort Sullivan in December of 1776. Or, a century later, by General P.G.T. Beauregard while rowing out to Fort Sumter in December of 1861.

I can hear some of you now. "Really, Suzannah! Aren't you carrying the Charleston thing about ancestor-worship I bit too far? I mean, equating Buffleheads to history? Isn't that stretching it a bit?" Maybe. But then, maybe not. One of the benefits of living in the Carolina Lowcountry is that our natural history is thoroughly intertwined with our social history.

First of all, we still *have* a natural history. We still have productive wetlands—even this close to a major city—that flocks of Buffleheads from the Canadian Maritime Provinces can continue to find, generation after generation. We also have habitats that remain fertile enough to provide Buffleheads and a host of other ducks with regular wintertime meals.

Walking the Old Bridge, I thought of all the Christmases that have gone before and some of the historic figures that might have watched a flock of Buffleheads as they carried out the orders of their day. Most specifically, I thought of the explorer John Lawson. It was on Christmas Day in 1699 that Lawson set out from Charleston to map and describe, for the first time, the "interior" of Carolina. This journey became known as "Lawson's Long Trail" and it eventually took him to where Washington, D.C. is now located. In a long canoe with two Indian guides, as he began to make his way north, he passed the same marshland vista that we still see from the Old Bridge. The Intracoastal Waterway wasn't there at that time, of course, but the old "Inland Passage" was—an interlacing network of tidal creeks that meander behind the barrier islands all the way to Bull's Bay.

What is amazing, my friends, is that the marshlands through which Lawson passed are *still there*. From the Isle of Palms northward to Georgetown, our coast is fringed by thousands of acres of pristine wetlands, which remain alive and productive three centuries later.

Moreover, we still maintain our sense of history. Like the Buffleheads returning year after year, our historic genetic memory gives us a deep-rooted sense of constancy and, thus, a security about this place we call home. Others may say we dwell too much on the events of the past. They may even laugh about the

Charlestonian's way of "revering" their ancestors. But, like our productive marshlands, the fact that we hold a rather extraordinary reverence for historic events is not an abnormality, but a treasure.

Despite the passing centuries, our history remains productive and alive, even within our present. This may be a difficult concept to get across on paper, but it is one with which we of the Lowcountry are very familiar. You see it's not that we don't forget—it's just that we continue to *remember.*

Last week, I wrote about how Christmas was a time of reflection, especially for remembering our friends. I have also jokingly written before that some of my "best" friends have been dead three hundred and fifty years. These are my historical friends—those fine men and women who went before and forged the way for the freedoms and unlimited advantages we people of today are so lucky to enjoy.

Though the centuries, the Lowcountry has seen many types of conflicts and its people have fought hard in the various wars this nation has undergone. One war we face now is of a different complexion—that of pure and simple greed—a fight brought on by the short-term desire for the almighty dollar. This, and only this, will cause the demise of our land areas, which presently remain pristine and untouched.

If we learn nothing else from history, we learn that our time on this earth is fleeting. It is what we do with this time that creates a certain historic immortality. We, the people of this day and age, must fight hard to be remembered as those who preserved not only the historic past, but also the ecological present we still enjoy and, by and large, take for granted.

Maybe, like the Buffleheads, our own heads are "buffled up" a bit with the importance of our history and our natural environment. If so, I don't care. My Christmas wish is that three centuries from now, one of my own descendants will be able to take a walk in a cold, December rain, gaze out upon a pristine marsh at a flock of Buffleheads frolicking in the tide, and appreciate what is there and the efforts of those who went before that allowed such a vista to endure. And, most of all, may we see you next year.

# Bibliography

Abbott, Martin and Elmer L. Puryear, eds. "Beleagured Charleston: Letters from the City, 1860-64." *South Carolina Historical Magazine* Volume 61 (1960).

Audubon, Marie R. *Audubon and His Journals.* New York: Charles Scribner's Sons, 1899.

Baldwin, Agnes Leland. *First Settlers of South Carolina 1670-1680.* Columbia: S.C. Tricentennial Commission.

Barnwell, Joseph W. "Letters of John Rutledge." *South Carolina Historical Magazine* Volume 18 (1917).

Batson, Wade T. *Wildflowers in the Carolinas I.* Columbia: University of South Carolina Press, 1987.

Berkeley, Edmund and Dorothy Smith. *The Life and Travels of John Bartram.* Tallahassee: Florida State University, 1982.

Bolls, Kate McChesney. "The Townsends of Edisto Island." 1977.

Brewster, Lawrence F. *Summer Migrations and Resorts of South Carolina Lowcountry Planters.* Durham: Duke University Press, 1947.

Bulger, William T. "Sir Henry Clinton's Journal of the Siege of Charleston, 1780." *South Carolina Historical Magazine* Volume 66 (1965).

Burton, Milby. *The Siege of Charleston.* Columbia: University of South Carolina Press, 1970.

Camp, Vaughn, ed. "The War for Independence, North and South: The Diary of Samuel Catawba Lowry." *South Carolina Historical Magazine* Volume 77 (1978).

"Carolina Huguenots 1690-1700." *Transactions of the Huguenot Society of South Carolina.* Charleston: Walker, Evans and Cogswell Co. 1897.

Carroll, B. R. *Historical Collections of South Carolina, Volumes I and II.* New York: Harper & Brothers, 1836.

Catesby, Mark. *The Natural History of Carolina, Florida & the Bahama Islands.* London, 1731.

*Charleston Year Book, 1884.* Charleston, The *News & Courier* Presses, 1884.

Clark, Thomas D. *South Carolina, the Grand Tour 1780-1865.* Columbia: University of South Carolina Press, 1973.

Clifton, James M. "The Rice Driver: His Role in Slave Management." *South Carolina Historical Magazine* Volume 82 (1981).

Cooper, Thomas, M.D. *The Statutes at Large of South Carolina.* Columbia, 1838.

"Correspondence Relating to Fortification of Morris Island and Operation of Engineers, Charleston S.C. 1863." New York: John J. Caulon, Printer, 1878.

Cronise, Florence M. and Henry W. Ward. *Cunnie Rabbit, Mr. Spider and the Other Beef.* New York: E. P. Dutton & Co., 1903.

Dalcho, Frederick. *An Historical Account of the Protestant Episcopal Church in South Carolina.* Charleston: E. Thayer, 1820.

"Descendants of John Jenkins," *South Carolina Historical Magazine* Volume 20, (1919).

Doar, David. "An Address given to the Agricultural Society of St. James Santee, July 4, 1908." Charleston: Calder-Fladger Co., 1908.

————*Rice and Rice Planting in the South Carolina Lowcountry.* Charleston Museum, 1936.

Drayton, John. *A View of South-Carolina as Respects her Natural and Civil Concerns.* Charleston: W. P Young, 1802.

Easterby, J. H. "Charles Cotesworth Pinckney's Diary." *South Carolina Historical Magazine* Volume 41 (1940).

Edgar, Walter. *South Carolina: A History.* Columbia: University of South Carolina Press, 1998.

Edgar, Walter B. and N. Louise Baily, eds. *Biographical Directory of the South Carolina House of Representatives, Volume II and III.* Columbia, University of South Carolina Press, 1977.

Edwards, George N. *A History of the Independent or Congregational Church of Charleston.* Boston, 1947.

Feduccia, Alan. *Catesby's Birds of Colonial America.* Chapel Hill & London: University of North Carolina Press, 1985.

Fleetwood, William C. Jr. *Tidecraft: The Boats of South Carolina, Georgia and Northeastern Florida, 1550-1950.* Georgia: WBG Marine Press, 1995.

Ford, Alice. *John James Audubon, A Biography.* New York: Abbeville Press, 1988.

Fortescue, J. W. *Calendar of State Papers, Colonial Series, America & West Indies, 1681-1685.* London: Eyre & Spottiswoode, 1898.

Furnas, J.C. *The Americans: A Social History of the United States, 1587-1914.* New York: G. P. Putnam's Sons, 1969.

"Fundamental Constitutions of Carolina," *South Carolina Historical Magazine* Volume 71 (1970).

Gibbes, Robert W., M.D. *Documentary History of the American Revolution.* New York: D. Appleton & Co. 1857.

Glen, John "A Description of South Carolina, Containing Many Curious and Interesting Particulars." London, 1761.

Gregorie, Anne King. *Notes on Seewee Indians and Indian Remains of Christ Church Parish.* Charleston Museum, 1928.

————*Christ Church, 17061769, A Plantation Parish of the South Carolina Establishment.* Charleston: Dalcho Historical Society, 1961.

Hamer, Philip M., George Rogers, David R. Chesnutt and C. James Taylor, eds. *The Papers of Henry Laurens (1747-1788), Vol. 1-13.* Columbia: University of South Carolina Press, 1968-1991.

Haskell, John Bachman. *John Bachman.* Charleston: Walker, Evans & Cogswell Co., 1888.

Heyward, Duncan Clinch. *Seed from Madagascar.* Chapel Hill: University of North Carolina Press, 1937.

Hicks, Theresa M. *South Carolina Indians, Indian Transactions and Other Ethnic Connections, Beginning in 1670.* Spartanburg: The Reprint Company, 1998.

————*Carolina Connections in the Colonial Period,* 2003.

Howe, George. *History of the Presbyterian Church in South Carolina.* Columbia: Duffie & Chapman, 1870.

Hudson, Charles. *The Juan Pardo Expeditions: Exploration of the Carolinas and Tennessee, 1566-68.* Washington: Smithsonian Institute Press, 1990.

————*The Southeastern Indians.* Knoxville: The University of Tennessee Press, 1976.

Irving, John B. *A Day on Cooper River.* Louisa Cheves Stoney, ed. Columbia: R. L. Bryan Company, 1969.

Ivers, Larry. "Scouting the Inland Passages, 1685-1737." *South Carolina Historical Magazine* Volume 73 (1972).

Jacoby, Mary Moore, ed. With George C. Rogers Jr. *The Churches of Charleston and the Lowcountry.* Columbia: University of South Carolina Press, 1994.

Jenkins, Sophia Seabrook. "Rockville, Wadmalaw Island, S.C." 1957.

Johnson, John. *The Defence of Charleston Harbor, including Fort Sumter and The Adjacent*

*Islands, 1863-65.* Charleston: Walker Evans & Cogswell, 1890.

Klingberg, Frank J. *Carolina Chronicle, The Papers of Commissary Gideon Johnston, 1707-1716.* Berkeley & Los Angeles: University of California Press, 1946.

Langley, Lynne. *Nature Watch in the Carolina Lowcountry.* Charleston: New & Courier and Evening Post Publishing Co., 1987.

Lawson, John. *A Voyage to Carolina Containing the Exact Description and Natural History of that County, Together with the Present State thereof And a Journal of a Thousand Miles, Travel'd thro' several Nations of Indians, Giving a particular Account of their Customs, Manners, &c.* London: 1709.

Leiding, Harriette Kershaw. *Historic Houses of South Carolina.* New York and Philadelphia: J. P. Lippincott Company, 1921.

Lewis, Kenneth E. and William Langhorne, Jr. "Castle Pinckney: An Archaeological Assessment with Recommendations." Columbia: Institute of Archeology and Anthropology, 1978.

Littlefield, Daniel C. *Rice and Slaves, Ethnicity and the Slave Trade in Colonial South Carolina.* Baton Rouge and London: Louisiana State University Press, 1981.

Mathews, Maurice. "A Contemporary View of Carolina in 1680." *South Carolina Historical Magazine* Volume 55 (1954).

McCormick, JoAnn. *The Quakers of Colonial South Carolina 1670-1807.* Dissertation Thesis, University of South Carolina, 1984.

McIver, Petrona Royall. *History of Mount Pleasant, S.C.* Charleston, 1960.

Meyer, Peter. *Nature Guide to the Carolina Coast.* Wilmington: Avian Cetecean Press, 1992.

Miles, Suzannah Smith. *A Lowcountry Garden of Verse.* Charleston: Kings Highway Publications, 1993.

Milling, Chapman J. *Red Carolinians.* Columbia: University of South Carolina Press, 1940.

Mills, Robert. *Statistics of South Carolina, including a View of its Natural, Civil and Military History, General and Particular.* Charleston: Hurlbut and Lloyd, 1826.

Moffatt, Lucius Gaston and Joseph Médard Carrière, eds. "A Frenchman Visits Charleston, 1817." *South Carolina Historical Magazine* Volume 49 (1948).

Moore, Caroline T. and Agatha Aimar Simmons, *Abstracts of the Wills of the State of South Carolina, 1670-1740.* Columbia: R.L. Bryan Company, 1960.

Moultrie, William. *Memoirs of the American Revolution.* New York: David Longworth, 1802.

Murray, Chalmers S. *This Our Land.* Charleston: South Carolina Art Association, 1949.

Nepveux, Ethel Trenholm Seabrook. *George A. Trenholm: Financial Genius of the Confederacy; His Associates and His Ships that Ran the Blockade.* Charleston, 1999.

Opala, Joseph A. *The Gullah.* Freetown, Sierra Leone, 1987.

Orvin, Maxwell Clayton. *Historic Berkeley County, 1671-1900.* Charleston, 1973.

Palmer, Colin. "African Slave Trade, the Cruelest Commerce." *National Geographic Magazine* Volume 182, no. 3 (September 1992).

Peckham, Howard H. *Narratives of Colonial America, 1704-1765.* Chicago: The Lakeside Press, R. B. Donnelly & Sons Company, 1971.

Potter, Eloise F., James F. Parnell and Robert P. Teulings, eds. *Birds of the Carolinas.* Chapel Hill: University of North Carolina Press, 1980.

Ramsay, Dr. David. *History of South Carolina.* Newberry: W.D. Duffie, 1858.

Ravenel, Mrs. S. Julien. *Charleston, the Place and the People.* New York: The Macmillan Company, 1906.

Reiger, George. *Wanderer on my Native Shore.* New York: Simon and Schuster, 1983.

Ringold, Mary Spence. "William Gourdin Young and the Wigfall Mission, Fort Sumter, April 13, 1861." *South Carolina Historical Magazine* Volume 73 (1972).

Rivers, Wiliam James. *A Sketch of the History of South Carolina.* Charleston, 1874.

Robbins, Walter L. "John Tobler's Description of South Carolina, 1754." *South Carolina Historical Magazine* Volume 71 (1970).

Rogers, George C., Jr. *Charleston in the Age of the Pinckneys.* Columbia: University of South Carolina Press, 1969.

Roman, Alfred. *The Military Operations of General Beauregard in the War Between the States, 1861 to 1865.* New York: Harper & Brothers, 1884.

Rosen, Robert N. *A Short History of Charleston.* San Francisco: LEXIKOS, 1982.

————*Confederate Charleston: An Illustrated History of the City and the People during the Civil War.* 1994.

"Roswell Sabine Ripley, 1823-1887." *News & Courier,* March 14, 1947, sec B.

Royall, Mary-Julia C. *Mount Pleasant: The Victorian Village.* Charleston: Arcadia Tempus Publishing Group, Inc., 1997.

————*Mount Pleasant, The Friendly Town.* Charleston: Arcadia Tempus Publishing Group, Inc., 2002.

Rutledge, Sara. With introduction by Anna Wells Rutledge. *The Carolina Housewife.* Columbia: University of South Carolina Press, 1979.

Salley, Alexander S. *The Early English Settlers of South Carolina.* Printed for The National Society of the Colonial Dames of America in the State of South Carolina, 1946.

————*Journals of the Grand Council, 1671-1681.* Historical Commission of South Carolina, 1907.

————*Narratives of Early Carolina 1670-1708.* New York: Charles Scribner's Sons, 1911.

————Warrants for Land in South Carolina. Historical Commission of South Carolina, 1910.

Savage, Henry, Jr. *River of the Carolinas: The Santee.* Chapel Hill: University of North Carolina Press, 1956.

Sharrer, G. Terry "Indigo in Carolina, 1671-1796." *South Carolina Historical Magazine* Volume 72 (1971).

*Ship Registers in the South Carolina Archives, 1734-1780.* South Carolina Historical Society, 1973.

Simms, William Gillmore. *The History of South Carolina.* Columbia: The State Company, 1940.

Smith, Henry A.M. *The Baronies of South Carolina.* South Carolina Historical Society, 1931.

———— "Old Charles Town and its Vicinity, Accabee and Wappoo Where Indigo was First Cultivated, with some Adjoining Places in Old St. Andrews Parish. *South Carolina Historical Magazine* Volume 16 (1915).

Smith, W. Roy. *South Carolna as a Royal Province.* New York: MacMillan Company, 1903.

Smith, Warren B. *White Servitude in Colonial South Carolina.* Columbia: University of South Carolina Press, 1961.

Snowden, Yates. *History of South Carolina.* New York: The Lewis Publishing Company, 1920.

Staudenraus, P.J. "Letters from South Carolina 1821-1822." *South Carolina Historical Magazine* Volume 58 (1957).

Stoney, Samuel. "The Autobiography of William John Grayson." *South Carolina Historical Magazine* Volume 48 (1947).

Swanton, John R. *Indians of the Southeastern United States.* Washington: United States Government Printing Office, 1946.

————*Early History of the Creek Indians and Their Neighbors.* Washington: Smithsonian Institute, Bureau of Ethnology, United States Government Printing Office, 1922.

————*The Indian Tribes of North America.* Washington: United States Government Printing Office, 1953.

Taylor, Rosser N. *Antebellum South Carolina: A Social and Cultural History.* Chapel Hill: University of North Carolina Press, 1942.

"The New South." *Harper's Weekly*, February 26, 1887.

*The War of the Rebellion, A Compilation of the Official Records of the Union and Confederate Armies, Series I, Volume I.* Washington: U.S. Government Printing Office, 1885.

Thomas, John P. Jr. "The Barbadians in Early South Carolina" *South Carolina Historical Magazine* Volume 31 (1930).

Tobler, John. "Description of South Carolina, 1753" *South Carolina Historical Magazine* Volume 71 (1970).

Trumbull, Robert. *Silversides.* New York: H. Holt & Co., 1945.

Twining, Mary Arnold. *An Examination of African Retentions in the Folk Culture of the South Carolina and Georgia Sea Islands.* Doctoral Thesis, Indiana University, 1977.

Waddell, Gene. *Indians of the South Carolina Lowcountry,* Columbia: University of South Carolina Press, 1980.

Wallace, David Duncan. *South Carolina: A Short History.* Chapel Hill: University of North Carolina Press, 1951.

Waddell, Gene. *Indians of the South Carolina Lowcountry.* Columbia: University of South Carolina Press, 1980.

Waring, Joseph Ioor. *A History of Medicine In South Carolina, 1670-1825.* Charleston: S.C. Medical Association, 1964.

Webster, William David, James F. Parnell and Walter C. Biggs, Jr., eds. *Mammals of the Carolinas, Virginia and Maryland.* Chapel Hill & London: University of North Carolina Press, 1985.

Wise, Stephen R.. Life*line of the Confederacy: Blockade Running During the Civil War.* Columbia: University of South Carolina Press, 1988.

Wood, Peter H. *Black Majority, Negroes in Colonial South Carolina, From 1670 through the Stono Rebellion.* New York: Alfred A. Knopf, 1974.

Woodward, C. Vann *Origins of the New South 1977-1913.* Baton Route: Louisiana State University Press, 1951.

Wordsworth, William. "Elegiac Stanzas, suggested by a Picture of Peeks Castle."